25.00

THE VALLEYS

POLLY & EMILY

THE VALLEYS ANTHONY STOKES

Introduction by Iain Sinclair

seren

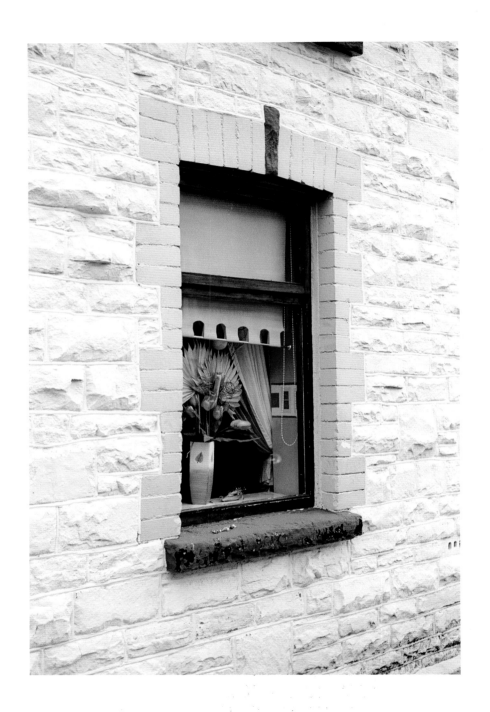

FUNERAL HOMES
& SMALL BRIGHT ORNAMENTS

Here it stops. The travelling shot of consciousness, through the screen of the car window, freezes; focus tightens. You are confronted by a country you have not seen before, not like this. A Wales that is actually inhabited by the Welsh. Reservations of ghostly traces. Cool depictions of hot colour. No middle-ground. A very steady gaze inviting your complicity. The world as a mirror of itself. The Anthony Stokes photographs wait for you to come to them, to come across to the very specific place where they are. They stare right back, right through you: through your prejudices and pre-conceptions. Dazzling brickwork, scarlet trim like a knuckle jabbed into the eye. Corrugated chapels. Abandoned petrol stations. Proud Victorian schools waiting for the right development package. And the windows of pristine dwellings, down those infinite contour-hugging terraces, are eyes too; milky and lost in cataracts of gauze. Net curtains laundered to a bridal shimmer. Doorsteps cleaner than the Formica tables of Hackney caffs. Votive figurines, gaudy but dignified. Secular and surreal: Swiss cows, French ladies, Roman gods. They are turned to face the street, the pedestrians, the human traffic that is no longer here. "These things," Stokes says, "are expressions to the world of what their owners are, what they want to be."

Most disturbing, this leap into colour. My early memories are monochrome; memories before memory, borrowings from stories told by grandparents, yellowing photographs of dead people when they walked on earth. When they dressed themselves, tightly, breath held, for camera inter-rogation, the studio. When they attended marriages and christenings. When they took holidays in Tenby, New Quay or Llanstephan. Funerals were not photographed, but obituary cuttings from local newspapers were preserved, until they became dust. Significant flowers powdering tin boxes where the unnamed and pre-forgotten are still imprisoned. Anonymous family snappers, with no title as artists, no self-consciousness. And the stiff cards with elaborate signatures of studio professionals. All of them, all these preserved fictions of the past, were black-and-white, sepia, discriminations of grey. Light sculptures in ectoplasm that have lived beyond their time.

My first years were spent in places where Anthony Stokes now chooses to point his camera. The reproductions of his work spread across my desk in London, those glossy-surfaced rectangles, are unblinking, forensic. Pin sharp. Without ambiguity and without – or so it seems – the tender rhetoric with which the industrial valleys are usually treated. I'm intrigued. You can never go back, I know that; the ground where you attempt this return will give way beneath your feet. The entire landscape, newly forested, dressed with development money, compulsory cycle tracks, heritaged history (the final colonisation), is trenched and wormed by shafts, tunnels, mine-workings. The bitterness of that story, the rape, the exploitation, the dust and ruin, the closure, will take generations to heal. The sights and sounds of the mining valleys in which I grew up go deeper than the particulars of East London, on which I have spent so many words. I've lived in Hackney for almost forty years, but I'm still a fly-by-night, a tourist who has outstayed his permissions. I believe that old London is a Celtic settlement,

all the energies, the lines of force down which crimes are enacted and visions accessed, begin at Tower Hill (the White Mount) with the buried head of the giant Bran. Lludd, the mythic founder of the city, builder of walls, decays into the sign on a pub at the foot of Ludgate Hill, the approach to St Paul's; where another incomer from the west, Prince Bladud, the English Icarus, falls from the sky. Triads from *The Mabinogion* are recycled in the graphic novels of Alan Moore. And legends of origin inform the work of the finest Anglo-Welsh poet and maker, David Jones.

> Did he meet Lud at Fleet Gate? did he count the top-
> trees in the anchored forest of Llefelys
> under the White Mount?

> from *The Anathemata (fragments of an attempted writing)*
> 'The Lady of the Pool'. London, 1952

Better, I found, to explore London as an overwhelmed Celtic camp than to wrestle with the matter of contemporary Wales, its politics and double-tongued promotions. It can't be done from outside. And you are expelled, make no mistake, as soon as you step on that train to Paddington. Dylan Thomas's abortive novel, *Adventures in the Skin Trade*, exults in a jaunty Celtic picaresque but finishes in self-lacerating defeat, beer puddles on the table in the station bar. The complex mass of the capital defied him. One pub, after a few hours, is any pub. There will be taxis, borrowed beds, stolen shirts. All too soon, like other defunct industries, the poet's name would be rebranded, attached to festivals, grim celebrations, conference suites in corporate hotels.

Once the site of childhood, the topography of the original dream, has been left behind, the way to recover Wales is by refraction: the recognition of other poets, other photographers who travel in the opposite direction, to carry out projects the emigrants have left behind. David Jones in London, in Harrow-on-the-Hill, excavates a cave of words and signs, a First War hut. The Welsh borders, the threadbare community at Capel-y-ffin, was impossible. And the limbo of Caldey Island was convalescent, damp monks and seagulls. It doesn't work for the native, it's all or nothing: the argument between social realism (chapel and mining once, later heroin and unemployment) and the unforgiving grandeur of our native geology; mountains, headlands, waterfalls, subterranean caverns. The incomer, with less baggage, can cast a colder eye, play for higher stakes. John Cowper Powys remaking Cymric mythologies in his exile in a quarryman's cottage at Blaenau Ffestiniog. The Liverpudlian Niall Griffiths forging a furious and multivoiced epic from communal life in Aberystwyth. Or the South London-Scot Chris Torrance, dug deep into Glynneath, marrying Charles Olson's open-field poetics with the historico-fabulous concerns of David Jones.

Making contact with Torrance, shortly after he moved across the channel from Bristol, where he had been working as a parks' gardener, in the early '70s, I recognised a writer who was doing a job I was incapable of undertaking. Or even attempting. The best I could offer was to publish, from London, his first three Welsh books: the sure-footed beginnings of *The Magic Door* cycle (which continues to this day, a diary of lyric fragments, nature notes and observations of fast-moving weather systems that read like love letters).

I photographed Chris, in his place, bearded, rusty with fieldwork, fingering stones: black-and-white portraits of an heroic enterprise, survival on ground that the local farmer had abandoned. A

guarded and watchful solitude. Poetry derived from a way of life that was no longer practicable. This was a useful preparation for the approach I received from Anthony Stokes: that I should write something, not a commentary exactly, to run alongside a selection of his photographs of the Valleys. (Visual artists, I remembered, just like the writers with whom I felt such a kinship, came from elsewhere: to recognise in the Welsh landscape, in the vertigo of the Valley roads, a special vision. Which all too soon swallowed them up, as naked obsession. Graham Sutherland in Pembrokeshire. Joseph Herman's miners. George Chapman mapping a route that Stokes would follow.) I realised, going back over Anthony's letter, that one of the elements that prompted his invitation was a notion that we had something in common. A partial Welshness, a few litres of heady blood, its glooms and glories. A connection with Bridgend, where my father, a GP, retired, after putting in his years, up the Llynfi Valley, in Maesteg. An idea Anthony had of alienation, difficulty, working-class warmth mixed with something colder, more calculating. From outside. Unlike me, however, he had taken the plunge, moved from London to a converted property, right on the road, in Ogmore Vale. Anthony believed, and his work set out to prove the thesis, that there was a distinct barrier between the coastal strip (aspirational, marina-ambitious, motorway-hugging) and the narrow valleys, terraces like a natural feature, winding north by river-road into the massif of the Brecon Beacons.

The small photographs on the table, they looked at me. I knew Ogmore Vale, as somewhere to be driven through, a moving landscape of the almost familiar, but I'd never walked its length, never packed a rucksack over the hills: which is to say, I didn't know it at all, in any way that matters. Would I have anything useful to add to the pictures that Anthony had made? A journey, I sensed, involving a car, repetition, scouting, novelty. The impression of a fastidious spy infiltrating a seductive and potentially volatile country. Here was hard evidence – of what? More refracted autobiography? An oblique confession? A catalogue of aesthetic prejudices? And where, I wondered, were the people? Where had they gone? I really didn't know, not then, what I could bring to a narrative that was complete in itself, in its steady and unflinching gaze.

Look closer. You find an enchantment, an abdication of metropolitan fret and status-struggle in favour of a leisurely logging of elements; a landscape that is out of time, unresolved. In transition. Memorials of discontinued industries. New money spent on new things. Hillsides learning to disguise their wounds. Religion, no longer choral and ecstatic, an assertion of community, is a matter of faint signs located by the photographer's eye for detail. A telegraph pole to which has been attached a funeral home advertisement, the announcement of a coming cremation. A white card, stapled to dark wood, covering up earlier sheets, curling moth-shaped fragments. This is a Welsh thing, a very local custom – art without intention – to suborn a utilitarian lump of street furniture to ritual purpose. To translate Calvinist timber into the Catholic object-fetishism of Spain or Mexico, a close-up by Luis Buñuel. The cremation notice on the telegraph pole, when you read it with enough care, lets you appreciate how Stokes' photographs are no random accumulation of interesting freaks, noticed by a benevolent outsider, but a narrative of connections; poetic metaphors disguised as matter of fact prose. The three Gethsemane crosses of the funeral notice will be picked up again in another print, the brick wall of Heddean Funeral Home, with its garishly frosted window. A cross, outlined in aquamarine, planted in an emerald-green hillock. There is further interplay between the repetition of cross struts in the two glass-fronted doors of the premises – and a trail of spectral reflections, from

the door frames, laying down a mysterious track. The two doors, handles facing in different directions, stand for Adam and Eve, Mary and Joseph, the human couple; while the three, the dark crosses, stand for death. Stokes, we assume, is perched somewhere in the middle of the road to make the shot. In these tight valley towns there is no margin, no middle-ground, nothing but the thinnest strip of pavement – if that – between through traffic and the elongated reef of shops and dwellings. One house, one chippy, one converted chapel: a curving cliff of brick, splashed with lurid Halloween make-up.

The melancholy of unsupported doctrine, falling congregations, which I derive from the bright surfaces of the Anthony Stokes prints, invokes the great Swiss-American photographer Robert Frank. I came to Frank through Jack Kerouac – who wrote a free-flowing and rhapsodic introduction to *The Americans*. Here was the exploration of a continent, undertaken in parallel to Kerouac's own frantic, coast-to-coast excursions. But Frank's European sensibility, his alienation (like that of Anthony Stokes), is less implicated. He watches the people, in cars, elevators, at political rallies. He observes death at the roadside. He is the absolute master of the shot that appears to take itself, an inevitable accident, camera held aloft, away from the prurient eye. Frank is always present in his frames. A whisper of mortality. His crosses, like the crosses noted by Stokes, mark out a bereaved land, the karma of material success and global domination. Beyond the sad cafeterias, the assembly lines, the 'hydrogen jukeboxes' (as Ginsberg called them), is the misty bayou, the voodoo priest. The old religion. Three crosses on US 91, in Idaho, marking an automobile accident; sunlight splashing bare hills. The statue of St Francis with upraised cross, warding off demons in Los Angeles, beside a gas station. A white-robed priest kneeling beside the Mississippi River.

Very slowly, which is just how it ought to work, I'm finding an approach to the Stokes portfolio. If you think about previous attempts to catalogue the experience of Wales, the ways in which this small parcel of land is unlike anywhere else, you go back to collections like *Land of My Father* by the Magnum photographer David Hurn. And already to have to manoeuvre around that title, with its subversion of cliché. Hurn has the eye, no question. But his travels remain a kind of reportage: Martin Parr configurations at the seaside, rows of natty boyos with pints balanced on party-sized cans at a rugby match. Much singing and signing. Many whispered asides. A story that explains itself all too well – and little that risks the awkwardly composed, off-balance confrontations of Frank in America. When Hurn relaxes and decides to go for the big lyric moment, it's an artfully lit Wordsworthian woodland, near Tintern – which arrives with the invisible subtitle: sublime.

Anthony Stokes in his practice is less the sophisticated visual practitioner, keyed up and ready for the Cartier-Bresson moment, the illusion of stilled transience, than a former painter slapping down an imaginary easel directly in front of the subject. And the subject is not going to move. Stokes notices that the blatantly white cladding on the wall of a tarted-up leisure shop reiterates the scraps of funeral notice on the telegraph pole. That wall is amazing: like a book in a wind tunnel, page after blank page stuck to wet paint. Then the new doors punched into a narrow slit. The inevitable replacement windows. The old terraces, snaking bravely up the valley, shadowing some brown rivulet, a weed-infested railway, are dressed to kill, chucking around surplus funds like lottery winners. Converting off-highway South Wales into an Andalusian retirement colony. Golf Shops for a Mediterranean lifestyle in a landscape of constant rain and hills too rough to be dressed with manicured greens and architect-designed sandpits.

The head-on approach pays off. The attitude of the photographer doesn't get in the way. He has no history here and we have yet to discover his bias, the secret prejudices. A man, moving out from a new house, interrogates his immediate surroundings; he travels, stopping when instinct nudges him, to make a portrait. A doll's house, impossibly clean and unoccupied, on the edge of a dark forest. The skeletal tower of a fire station, grey and minatory: a phantom border post. A blue bus shelter with the trunk of a naked tree framed in its panels. A pink phone-box, peeled skin, against the rough-stone wall of a school. A green car in front of a matchingly queasy 'Cyber Bar & Grill'. Shock effects that terminally depressed, light-deprived Norwegians employ to get themselves through absolute winters: scarlet fish-huts, blue tin shacks.

It's when the mist rolls down from the hills and Stokes positions himself for a long shot, with road and sheds and even a pair of remote pedestrians (in territory where nobody walks), that I'm convinced of the kinship with Robert Frank. With that grey-at-the-edges, obliquely angled shot of the Chinese cemetery in San Francisco. They're saying the same thing, these men, in very different ways: life is solitary, bleak and beautiful. If you stand in the right place, for a nanosecond, you'll see it.

My underlying motive for a return to Wales, a visit to Anthony Stokes, was now clear. I couldn't assume, from looking at the work he'd sent me, that this newcomer to Ogmore Vale had any particular interest in or knowledge of Frank's Welsh project – published in the collection *London/ Wales* in 2003. This book was one of my absolute cornerstones, East London and the City intercut with a photo-essay on a Welsh mining town. Or the life of a particular miner in a very particular environment, Caerau. At the head of the valley where I grew up, the place where my father had a surgery; the landscape through which I had walked, time without number.

In my only novel with a homeland setting, *Landor's Tower*, I talked about a particular Frank photograph from the Welsh series. It was taken in Caerau, in 1953, and it shows a group of scrawny kids, just the age I was then, with a dog, scuffling on an overgrown slagheap. I haven't got over the surprise, coming to Frank by way of Kerouac and the epic of America, of discovering that he had visited my home town, years before I was aware of his work. And that he might, for all I knew, have pressed the shutter on a childhood expedition that was now totally erased from my memory. That is the mysterious power of the photograph. It really does indenture your soul, when you least expect it. Those Caerau kids, dead, worked out, emigrated to London or America, are fixed, in place: when the place where they were and the mine workings behind them have gone forever.

There was one other photograph in the series, the last, which caught me. A narrow strip of graveyard, attached to an unseen but half-familiar church, a stone angel. And, beyond it, a house I'm sure I've walked past, noticing and not noticing; a house with a huge advertisement for *News of the World* on its end wall. A forbidden Sunday paper. Enough to let us understand that there was a world elsewhere and news that we would never hear: unless we rode out of this narrow, claustrophobic, all too real place. Frank writes a few lines beneath the print:

> Leaving the villages of the Coal Miners I passed thru Maesteg to get on the train for London. I walked by a Graveyard and I must have looked carefully at that gesture from the cast stone Angel near the entrance, Holy hand raised to the lips – The sign for silence ... My absent memory rests within these photographs.

"Leave the M4 at exit 36 (Bryncethin + Maesteg)," Stokes emailed. "When you enter Ogmore Vale, bear left at Remax (estate agent). Your drive is likely to be 180 miles." The known road was less known now. After my parents died, in Bridgend, we came down from London infrequently. Our children were grown up, no more trips to the sand dunes at Merthyr Mawr, no limestone pavements at Southerndown and Monknash; no picnics with the grandparents, catering – formidable as a Victorian expedition – spread across a convenient lay-by on the edge of the Brecon Beacons. Visiting Anthony Stokes was reacquainting myself with the picturesque, the breathing space between the soft coastal plain, overwhelming surface respectability, and the sudden and spectacular otherness of the Rhondda. The snaking road. The balding custodian sheep. And the slap of wind as you step from the safe pod of the car into proper weather and a view you struggle to articulate.

"Bear left at Remax." The final frontier has fallen to estate agents. They are selling the unsaleable: a place of exile for urban artists. If properties pass on, as they once did, from father to son, you don't need an estate agent. Most of the terraced houses, as I remember them, were rented. A practice that sustained the valley caste of middlemen: solicitors who wrote poetry, local politicians with a fix at the rugby club, chapel elders, the Masonic brotherhood. "I think it's very significant," Stokes told me, "that, because Cardiff house prices are approaching London levels, a lot of young-sters realise that once they're on a little salary, a couple both on salaries, they can live in the Valleys. The rates aren't too bad. From here to Cardiff doesn't take very long – if you drive. I think it will become apparent that Cardiff people can afford to buy here."

And they do drive, clearly. The money goes into cars. That serpentine, black-and-white road (out of George Chapman), insinuating a passage between colliery workings, sooty scars, and close-forested hillsides, hidden traces of rough farming, is a rivulet of gleaming German metal. The motors have more equity than the houses. The houses, in essence, are garages for people; shelters built to accompany this fabulously polished showroom of Jeremy Clarkson merchandise. Indian, Russian and Brazilian conglomerates are eyeing up Corus, the steel giants of the Welsh littoral, whose products have colonised the Valleys: a twisting ladder of customised trophies asserting a new confidence, a cargo cult lifestyle.

"You see a BMW outside a tiny miner's cottage," Stokes tells me. "I'm not sure how healthy it is. They don't have gardens to walk across. They park their cars outside their houses and they drive to work. They might have a factory job. They eat quite badly. There are a lot of fat people about."

Anthony Stokes is lean and slightly wary. A man of about my age, in shock, surprised and excited to find himself in this place, a restored cottage perched over the valley, clamped to the road. And, meanwhile, the territory around him asserts its kinship with redneck America: genetic mutation, jumbo kebab-burgers curried with extra chips, line-dancing, retail park drive-ins, punishment colony superstores. Monster caravan parks: Guantanamo Bay meets Trecco Bay. Residual Celtic depression countered by consumer bravado.

There is a pot of coffee on the table, photographs of attractive, bright-eyed daughters on the wall. A high-concept, Hoxton loft-living lamp, silver with Vorticist cones and arms. Racks of large books by the currently acknowledged image masters: Saul Leiter, William Eggleston, Robert Frank. Yes, Frank. I'm delighted now that I accepted the invitation, to come home. Anthony Stokes, aluminium hair, raised brows, leaning back in hard chair to accommodate a painful back, cigarette,

reminds me of somebody: a civilised and courteous version of Klaus Kinski in *Fitzcarraldo*. That white-suit madness, to bring opera to the Amazon, to carry a paddle-steamer over the mountain. Stokes, quietly, has that determination. A presence from another world, with a job to do, making art of the circumstances in which he finds himself. Walking out, taking photographs to assure himself that he is really here. A suspect. Watched from behind curtains. Reported. Visited by the police. The camera, on such non-conformist turf, is still the devil's instrument. So Anthony, like all the rest, climbs into his car and sets off. The point of his journey is to have no point, to lay himself open to incidents of the actual, object-arrangements that don't know that they're photographs.

"Time doesn't seem to be an issue when I'm down here," Stokes said. He quotes Walker Evans, the lyrical recorder of the American Depression, elegies from hard times:

> ...there's a wonderful security in a certain place and I can capture it. Only I can do it at this moment, only this moment and only me.

You need that kind of hubris to relocate to the Ogmore Vale, its heritage, the road, the people. "I didn't feel it necessary at that point to pursue what the history of place is. I'm not looking at that. What I'm doing is making a picture. And I find that sometimes I'm attracted to a place where I think I'll be able to make a picture and it doesn't reveal a picture. But somewhere else will. I don't know why it is. It's something to do with the place and something to do with my attitude, no doubt, when I get to that place."

Anthony Stokes has been following a subplot, he wants to identify the locations where Robert Frank took his photographs in 1953. The theme that was put to me, as a pitch for this Welsh excursion, has some truth: that we, two men of a certain age, a certain damage, have common interests, a common background. Packing a copy of the Frank originals, the Stokes colour duplicates, we step outside to the car; to drive, like Eddie Constantine in Godard's *Alphaville*, into the future by way of the past. By being wholly selective in what we see. Architecture prepared to look good in a photograph. Terraces, views that offer themselves up to an ironic, detached vision of human history. Place as a form of refracted autobiography. Image as truth. Memories made from fruitful accidents.

I've walked with the painter Jock McFadyen through East London, and driven down the A13, visiting places that featured in his work. He would always acknowledge them, offer a passing salutation, before moving on: captured on canvas, his subjects were no longer themselves. They didn't radiate the same energy. A pink block-building close to the canal in Hackney could be shifted, if the composition required it, downriver to the Thames Estuary. It could be symbolically rehoused in Dagenham, like so many postwar citizens of the bombed inner-city boroughs.

Stokes wouldn't contemplate such trickery. He is attracted by painterly effects: the rusty blush of corrugated sheets, bolted together to make a garage or shack, against low-lying blue-grey mist; rain puddles on grit. The technique recalls William Carlos Williams and the Imagists: thing-ideas. Traces of human activity without human interference. Angles of sharp ascent, precipitous roads: they suggest a deadpan irony. Nothing as blatant and elbow-nudging as Martin Parr. The caravans (curtains drawn) that Stokes features are just caravans, colour-blocks against a brick wall, with the trade

name, PERLE, as an alchemical adornment; pearl of the valleys. A hidden jewel discovered – but never stolen, carried away. Witness borne. Picture made. The catalogue of Stokes photographs, examined at leisure, is a stoic requiem; a tribute. The fine texture of pebbledash, a vertical beach, is exposed: as it plays against a red-eye window, decorative lace curtains, a crinkled asbestos roof.

It's a driving art, benign tourism. We visit a few of the sets that I recognise from prints Anthony has shown me. But the day finds focus when we both realise, with some anticipation, that we are returning to the Llynfi Valley, Maesteg, the town where I grew up. Except of course we can't, I can't. It isn't there. We might as well navigate by Robert Frank's 1953 portfolio, the erased biography of the Caerau miner, Ben James. The original photo-essay is a record of a life shared, however briefly; a human register that no longer exists, not here, not in this country. A poetic documentation inspired by the novels of Richard Llewellyn, but going far beyond them, the sentiment, to D.H. Lawrence.

The house where I lived, or my family lived, for the first eighteen years of my life, was pretty much unchanged; its quirks unimproved. Arts and Crafts detail, diamond pattern decoration, glass-roofed porch, bowed windows and a gritting of early pebbledash. Photographs are made that echo earlier versions of themselves, different agendas. And then we park the car and begin to walk through the dream of what is always there, unsourced and unsoured, the real fiction of memory.

Having to tell a tale, to pitch my past, suggests a direction for our ramble. I'm 'explaining' this place in terms that might suit the Anthony Stokes project. And our mutual recovery of Robert Frank's postwar expedition. We drift towards the old/new railway station, from which, many times, I set off for destinations east, for Cardiff and London. We want to pin down that Frank angel, the little graveyard he passes – and snaps – as he leaves Maesteg for the last time. It's not there. The station has been shunted. The track doesn't continue up the valley. We photograph the terminal buffers, the end of the line. Nearby, the chapel which I sometimes attended with my great-aunt, to support wild-eyed preaching relatives in long black coats, has relaunched itself as a funeral parlour: a clean-'em, dress-'em, service-'em, bury-'em package. The Masonic Temple, where both my grand-fathers (Scottish and Welsh) paid their dues, is untouched. My paternal grandfather's surgery, by the tin-coloured river and the now-removed railway bridge, is located. My father, returning to help his sick father out, never left. He met my mother, dispenser of pills and potions, in this house.

Climbing above the surgery gives backdoor access to the rugby ground on its sculpted dune of recovered slag. The view towards the hill, Mynydd Bach, is classic Frank: a horizontal band of cottages. A scene which can now be translated into colour by Anthony Stokes: burnt-red plastic melting over tall brown weeds. Deserted out-of-season rugby fields are sad places. Youthful glories that will never be repeated. Political prisoners herded, in another country, into a convenient pen. The small stand, new to me, has been dressed with seats taken from the old national stadium, Arms Park. The OLD of 'Old Parish' (black letters on yellow wall) features in the photographs we take. We are old, in an old place that is coming back to a different life: of heritage centres, foundries with bilingual brochures about 'Strengthening Wales's Cultural Identity' by talking up the 'Guardian Hay Festival', that tented horror show (impractical to get to, impossible to get away).

I explain the 7777 motif that gives the Old Parish its name, the myth of an innumerate mason in Llan who, unable to write 28 as the age of death (or being unable to carve those figures), cut 7777 instead. The numbers, on kiosks and brick scoring-booths, give the rugby field a suitably

cabbalistic feel: older than Egypt, this game, these rituals, the floodlit patch of grass and clinker in its emerald bowl. Anthony Stokes is taken with red houses against grey-green hills. With miniature gardens, of almost Japanese formality, in fresh built suburban-aspirational avenues. With yellow cars parked outside the rugby ground, yellow (amber) logo: double-yellow lines on an empty road. Maesteg, in 2006, has the ambition of being everywhere, like other towns, economically viable, proud of its civic identity, litter free, ecologically sound. Down by the bus station, behind the covered market, sit the only tolerated vagrant drinkers, clinking cans on a very clean bench.

We returned to the car, drove to Caerau, Frank's patch. Stokes, taking a small track that led to a terrace of solitary cottages, was able to identify the position from which the Swiss-American had made his shot, across the valley, to the old slag heaps: the flattened Silbury Mound, the black pyramid. 'Caerau, Wales' (1953). From the collection of the artist. A gelatin silver print. A copy of which Anthony Stokes holds in his hand, against the present, colour-flooded reality. The mounds are gone. Scars have been grassed over. The slope, immediately beneath us, is dressed with a carpet of flowers, white, purple, red. Hard plastic bucket-seats have been bolted to the ground as a viewing platform, as if to honour the memory of Robert Frank's landscape portrait.

And, of course, standing there, we are ourselves objects of curiosity. The householder – gardener and archivist – emerges. His name is Lyn Thomas John Morgan and he is the self-appointed custodian of place. And of heritage. He collects miners' lamps and has an album of photographs and news cuttings. He recorded, stage by stage, the removal of the slag heaps. Outside the cottage, in pride of place, was a Surrey-rep or Essex-footballer motor; a dazzlingly bright, silver Jaguar, with radial spokes on the tyres like burnished shields. The ruined pub, far below, so Mr Morgan tells us with a breathtaking absence of political correctness, was called Monkey Island, not after the powder monkeys of the industrial past, but after a group of black immigrants who lodged there. The dead-end estate of fearsome reputation, once occupied by the wild Irish, imported to dig the pits, is now squatted by displaced Liverpudlians, Asbo exiles from Newcastle, Glasgow junkies. The new pastoral, of terraced gardens and expensive motors, is balanced as ever by smack legends, broken windows, burnt-out shells: survivalist piracy.

The day, and my visit, concludes, as it has to, at the hilltop village of Llan. It was where my parents married, where many relatives, on my mother's side, were buried. The village inn, the Old House, is a gastro-pub, with a wide range of wines and walls thick with heritaged plunder; forgotten rugby players, lost teams, rivers before they were polluted, local myths and polished legends. All under the shamanic symbol of the Mari Llwyd, the horse's head, beribboned and dug up, once a year, on New Year's Eve: so that the frozen dead can return to challenge the living to a rhyming contest, to demand access to fire and hearth.

The church is locked, but our presence has been noted, and a lady, tidying a memorial, has the key to let us in. A plain, whitewashed interior with a very particular smell: of wood and damp mortar and the curdling of time. Out of a creaking cupboard, ledgers are produced. I find the record of my christening, from September 2nd 1943, a Thursday in war. My parents' wedding anniversary. It's a strange moment. Our guide, asking who we are, doesn't remember my father – which would once have been an unusual thing and the only way I could make myself known. Father and grandfather

before him had been general practitioners in Maesteg long enough to become fixtures, part of the landscape: like the Town Hall turret or the winding-gear of the collieries. My grandfather arrived from Aberdeen some years before the First War. "But I know you," the lady said. "I've read one of your books." Which threw me completely.

We climb the slope of what we are told is 'the biggest graveyard in Europe'. And we discover the red granite of my maternal grandparents' grave, the headstone tipped over, folded down as a potential risk. The striking view is back towards the church, a long straight path. I am reminded of how Stokes frames his compositions: either upwards at pink or red walls, or down to distant terraces, a church in an unexpectedly green valley. His irregular, rain-grey houses are like gravestones. His vegetation is tangled, fed on poisons; bushes knitted out of barbed wire. In Llan everything is lush and fat and quilted. The dead ones are comfortable with each other, the company they keep.

We turn for our retreat to the pub, Stokes' veteran Mercedes – and, suddenly, I see all my childhood neighbours. Their names and details in gold, on well-kept granite. Oversize visiting cards. The Llan slope is a replica of Neath Road, the steep street on which I grew up. A suburb of heaven. The people I knew have been translated to this other estate; doors in the ground, names instead of numbers. I photograph the stones, like an electoral registrar. But this is too specific a remembrance for Anthony Stokes. His landscapes do the same thing in a more subtle way. They are not personal. His back story is elsewhere. The world he delineates, with such precision, is not somewhere that he is obliged to correct or improve. As patrons of his work, we are allowed to make our own connections. The relation to Robert Frank is oblique, unstressed. The necessity for any kind of introduction or explanation falls away. Images are images. Records of encounters from which the initiator has withdrawn. I have, in the course of a single day, learnt to give these photographs their space. In time, the specifics of a singular vision will forge their own legend. Allowing the artist, the photographer, to stand clear – while the viewer, as witness, steps through into the shock of an eternal moment.

IAIN SINCLAIR

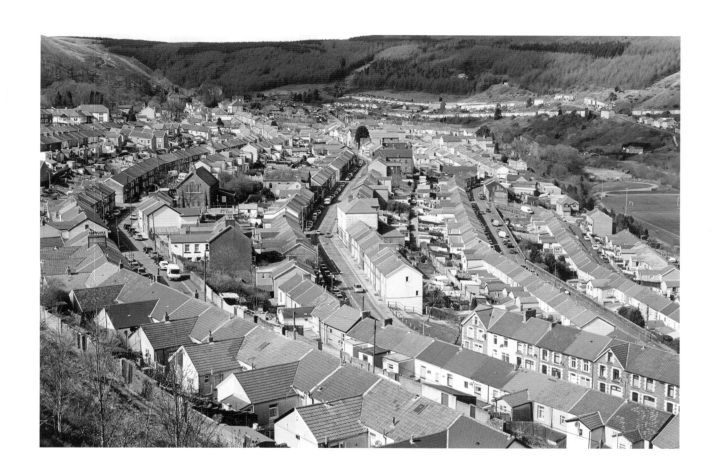

Townscape, Ferndale

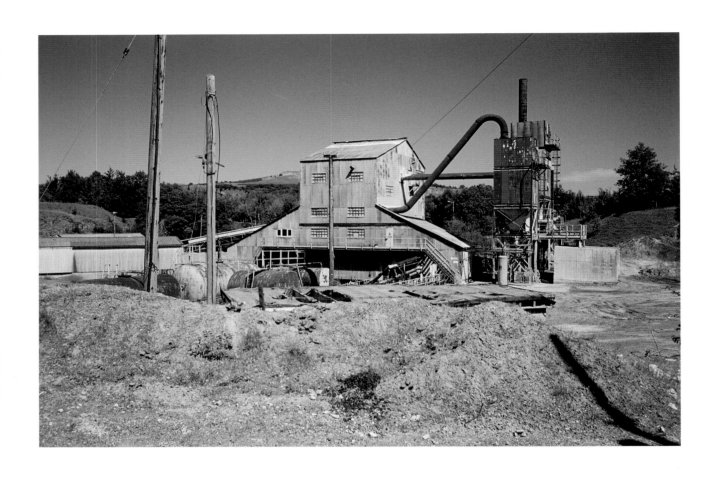

Aggregates, Trefechan

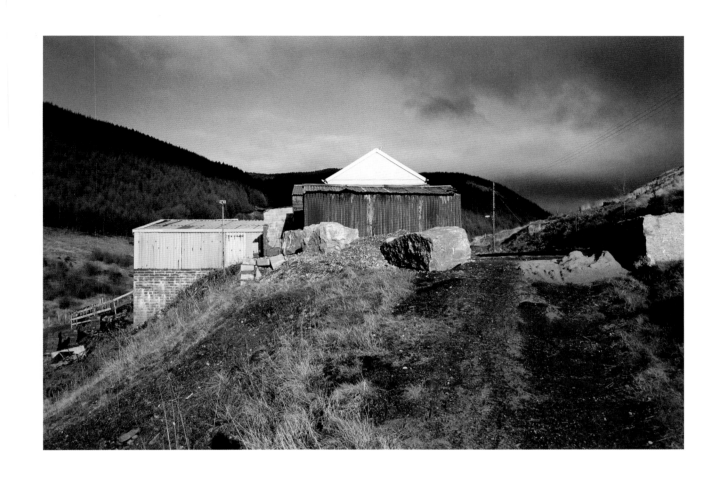

Outbuildings, Glyn Corrwg

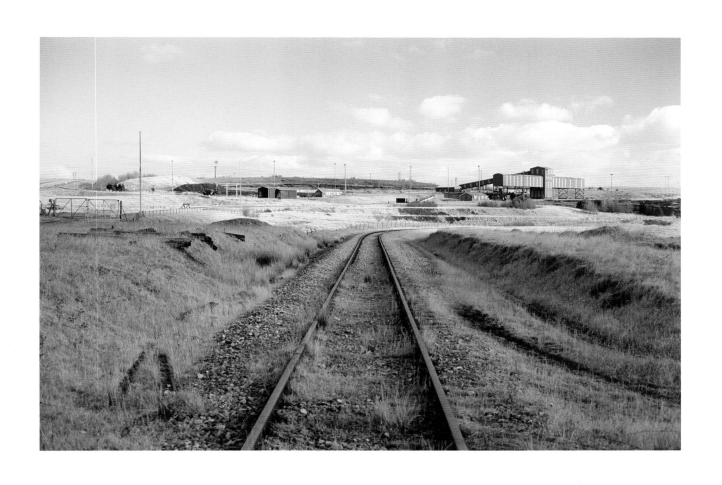

Distribution Centre, Cwmbargoed

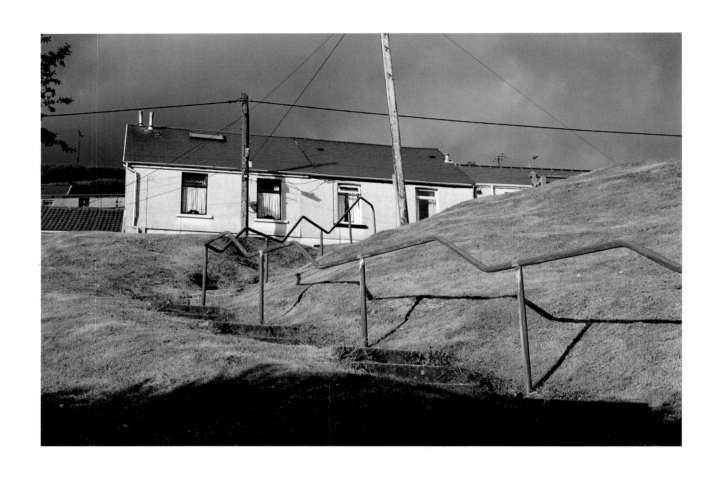

Handrail, Nantymoel

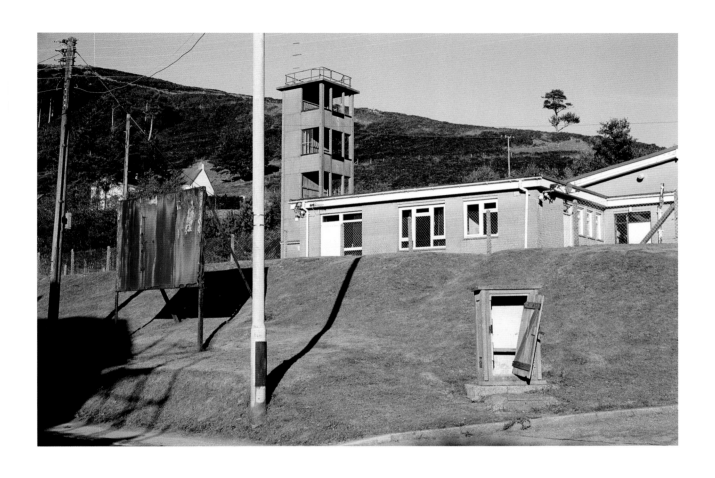

Firestation, Ogmore Vale

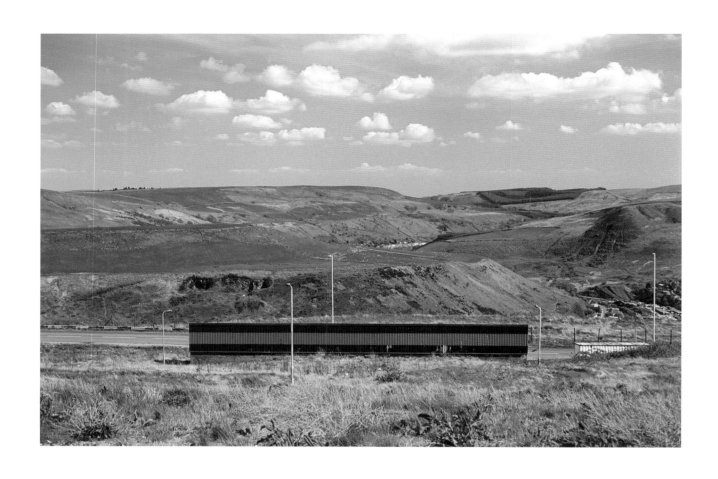

From Penrys to Tylorstown

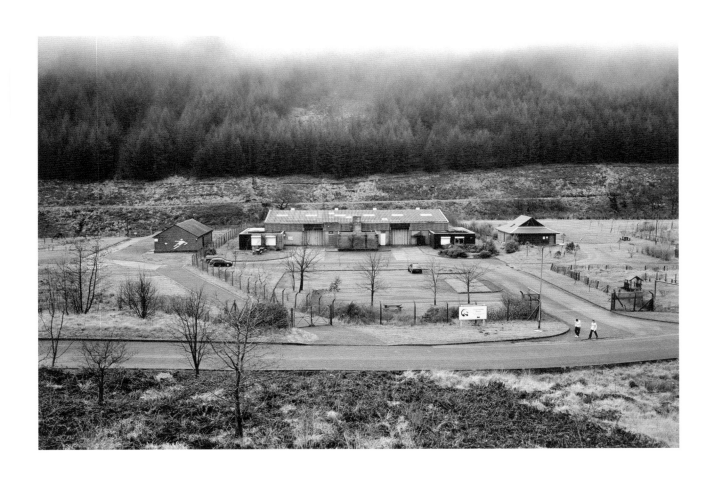

Sports Centre, Glyn Corrwg

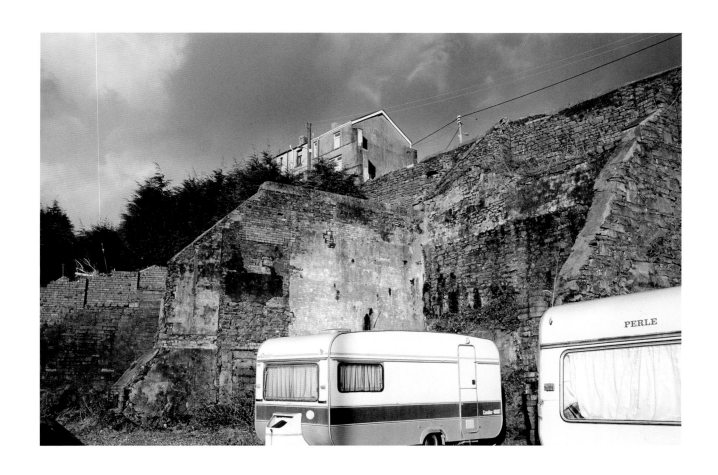

Perle, Pontycymer

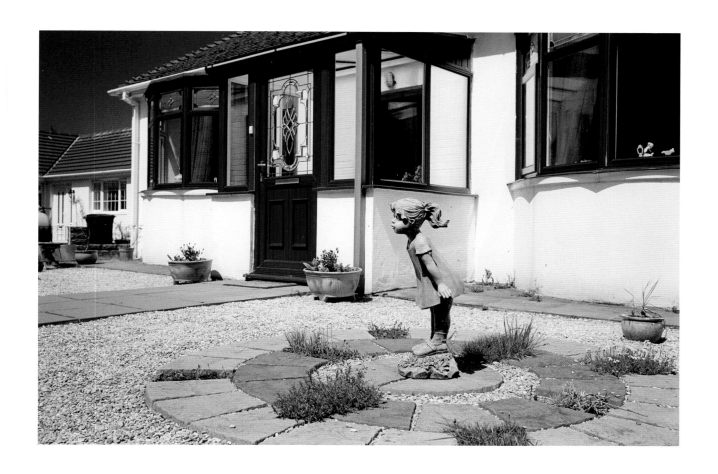

Girl, Cymer

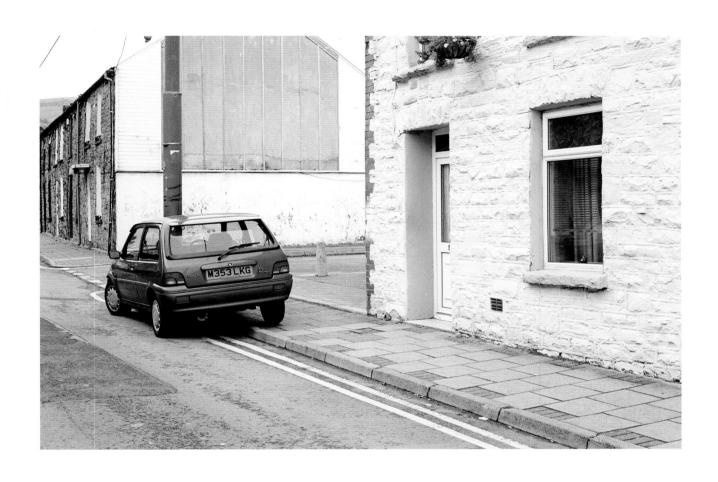

Buddha, Blaenrhondda

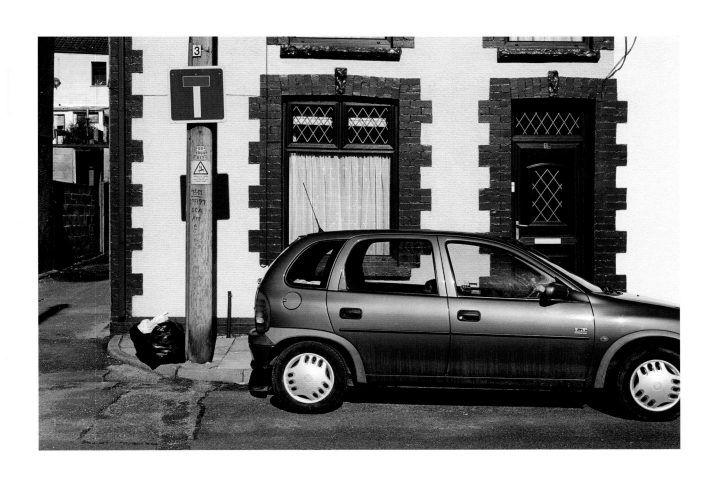

No Through Road, Cwm Parc

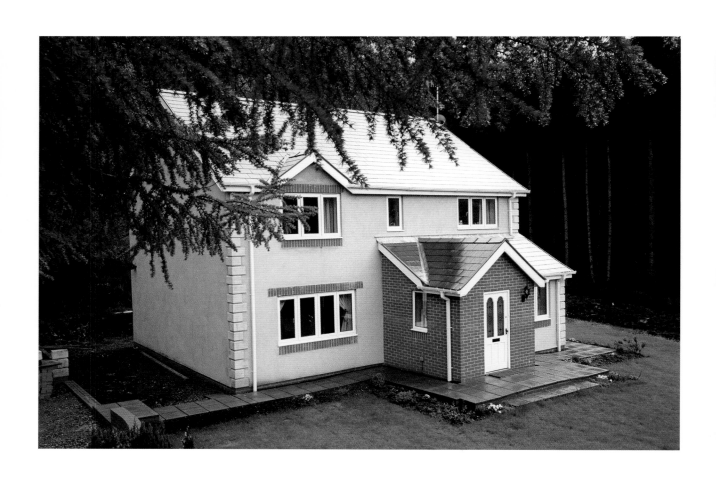

New Build, West of Cymer

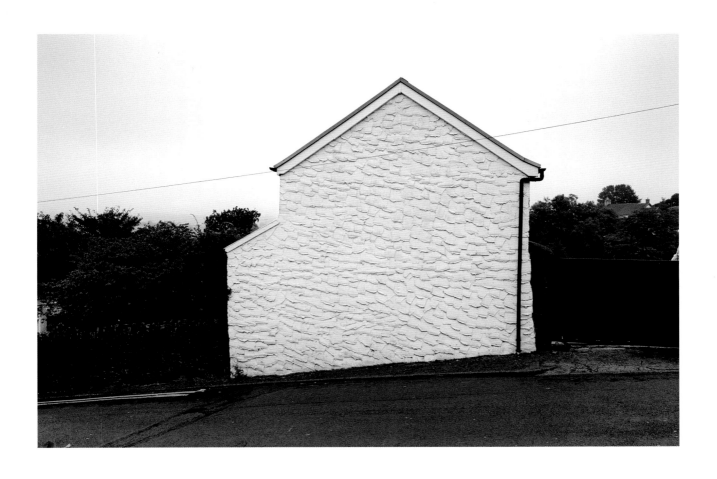

Pine-end, Llantrisant

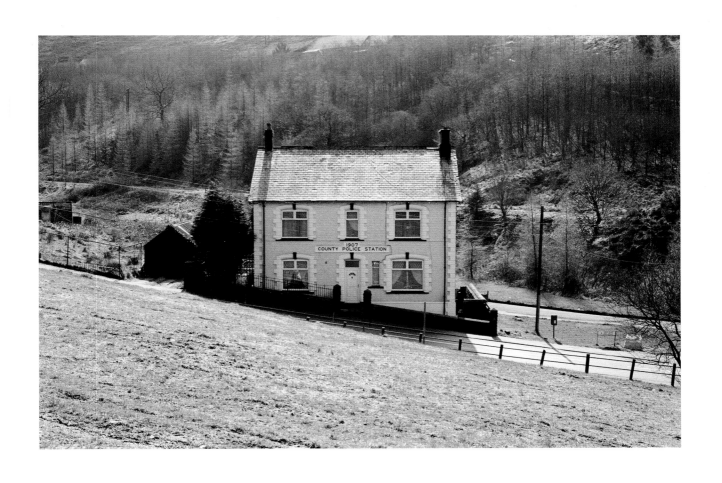

County Police Station, Blaengwynfi

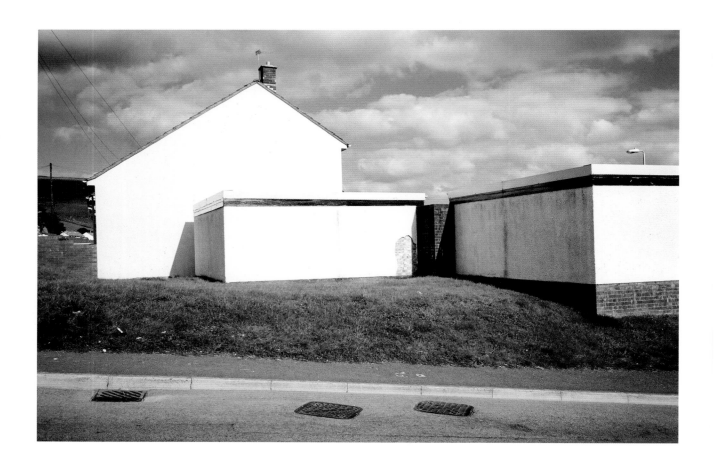

Three drains, Tonyrefail

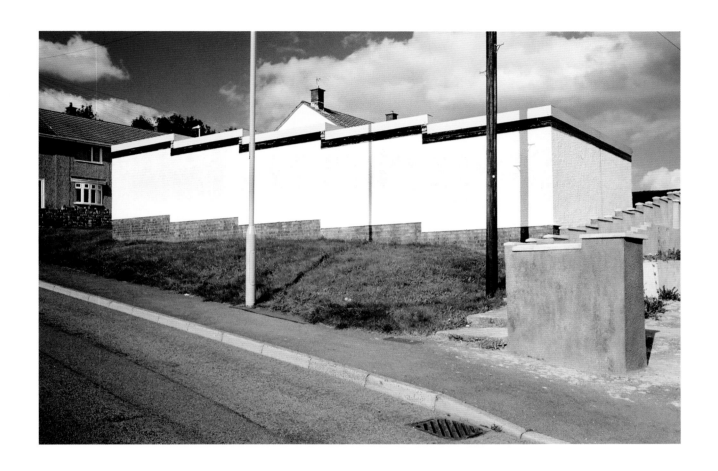

Two posts, Tonyrefail

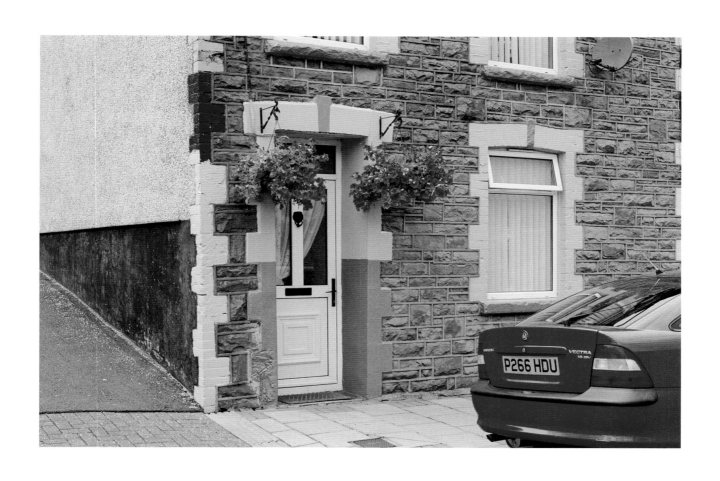

Petunias, Maerdy

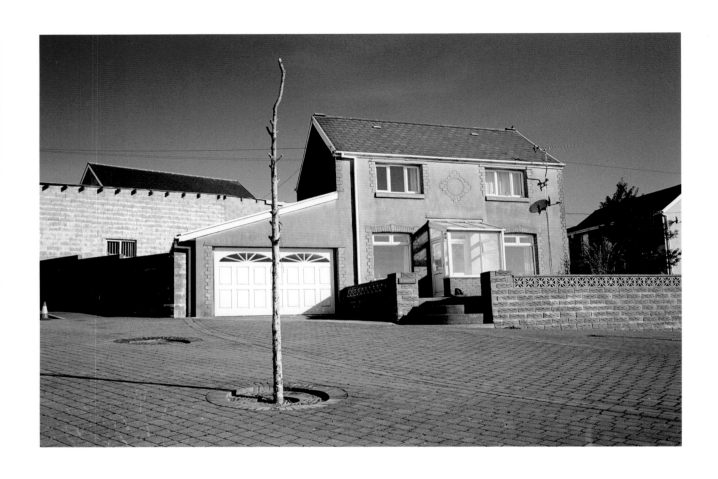

Pruned tree, Bettws

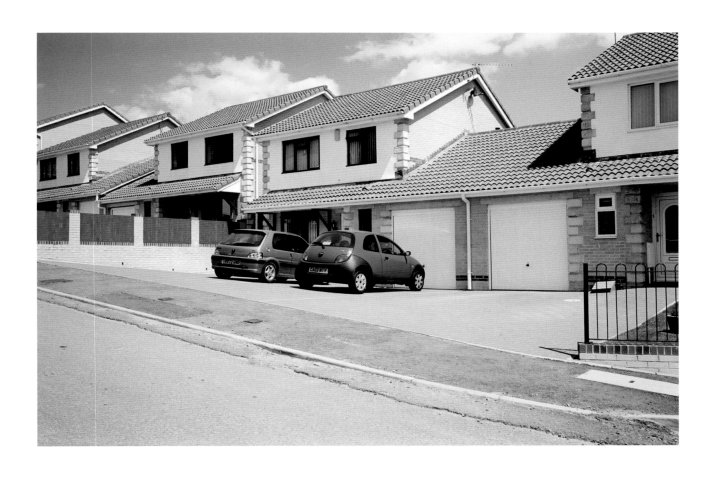

Pen-y-Waun

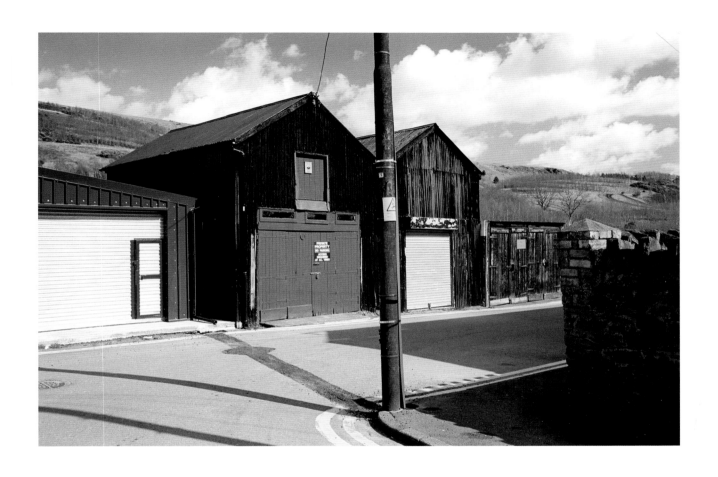

Private Property, Cymmer, Porth

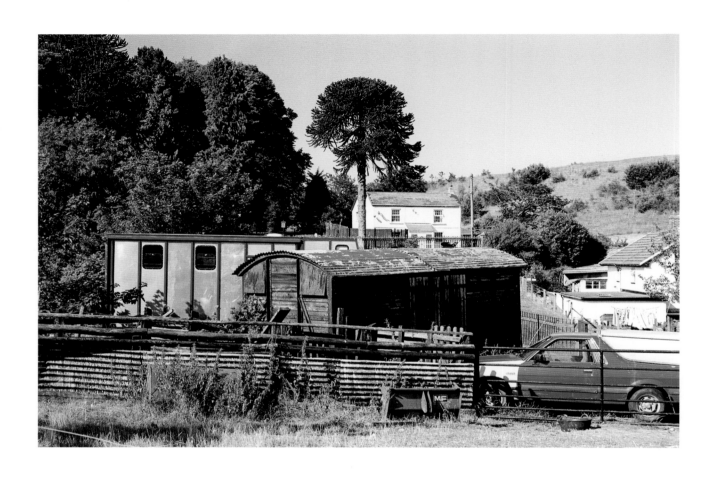

Araucaria, east of Merthyr

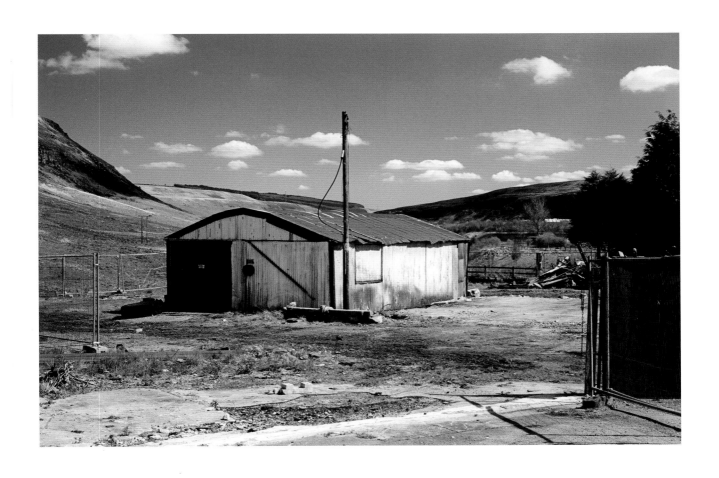

Shed, Maerdy

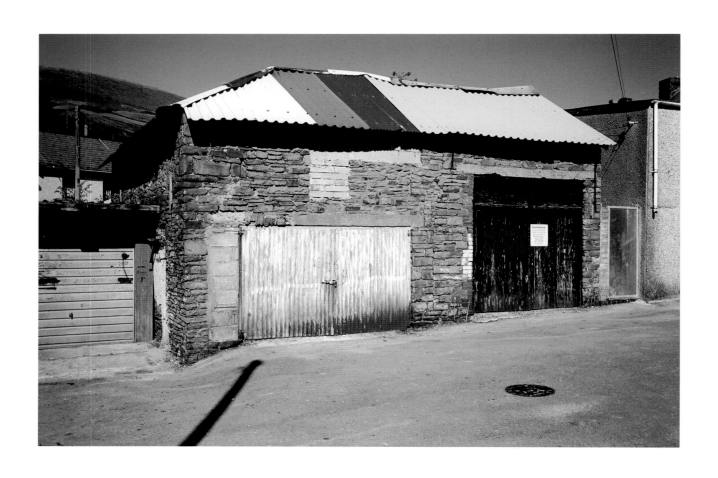

Phil's garage, Ogmore Vale

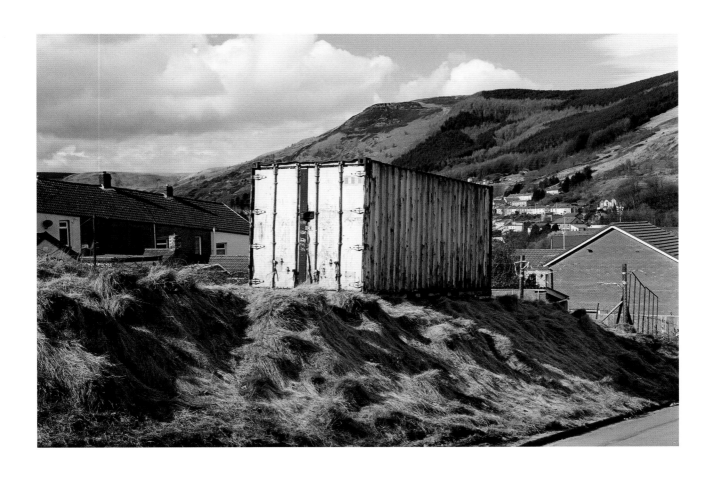

Container, Ton Pentre

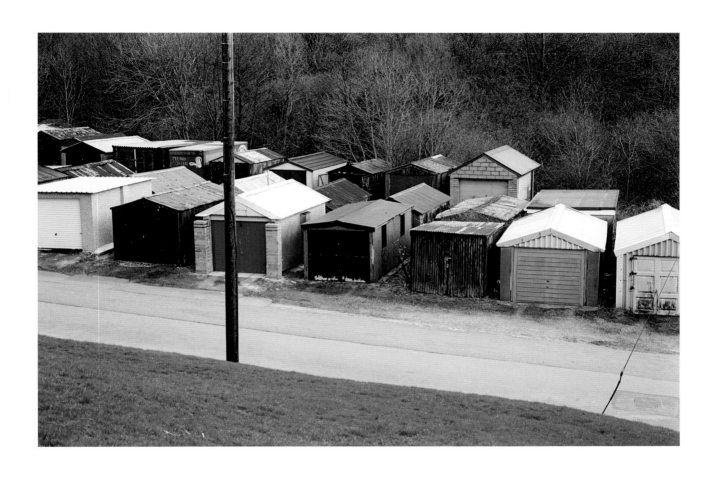

Garages, Cwmavon

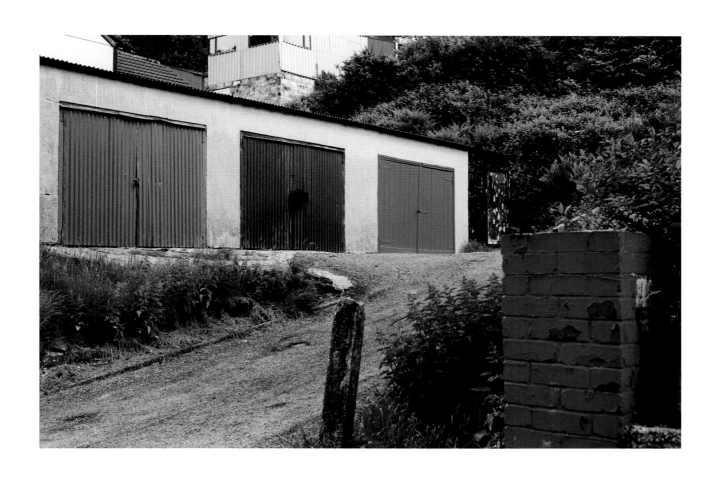

Green, Brown, Red, Glyncorrwg

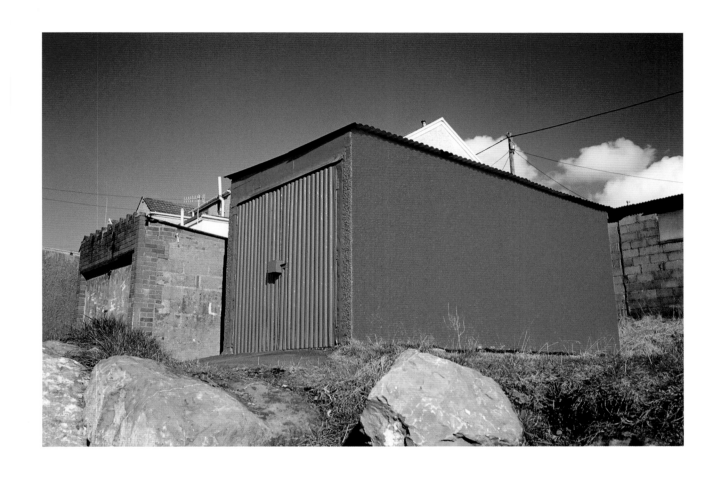

Garage, Garth, Maesteg

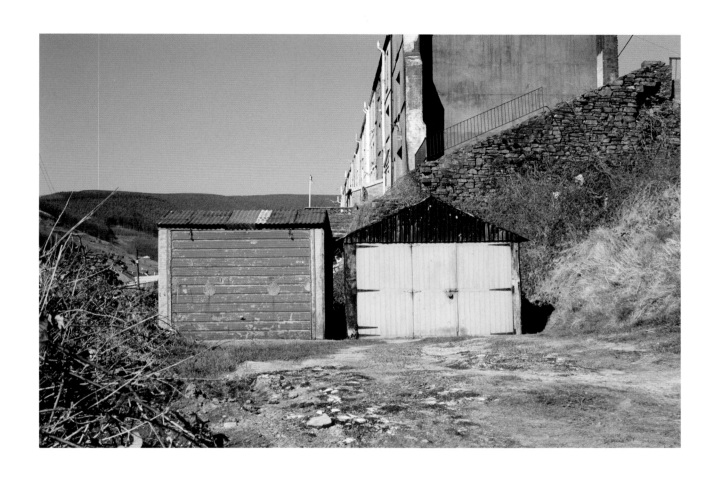

Two garages, Pontycymer

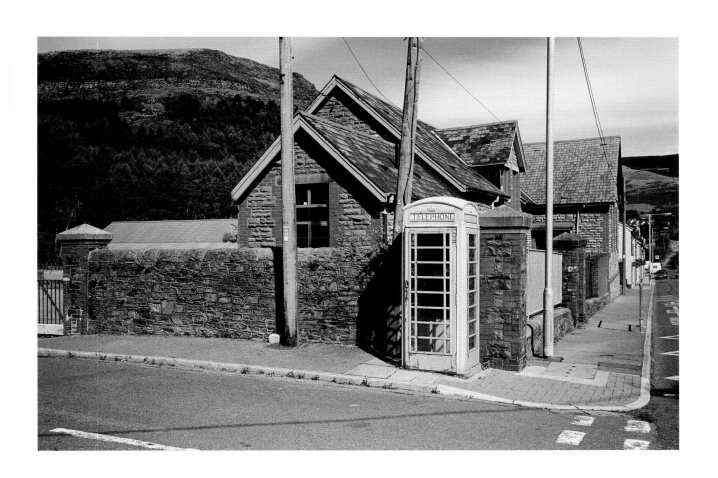

Kiosk, Blaengwynfi

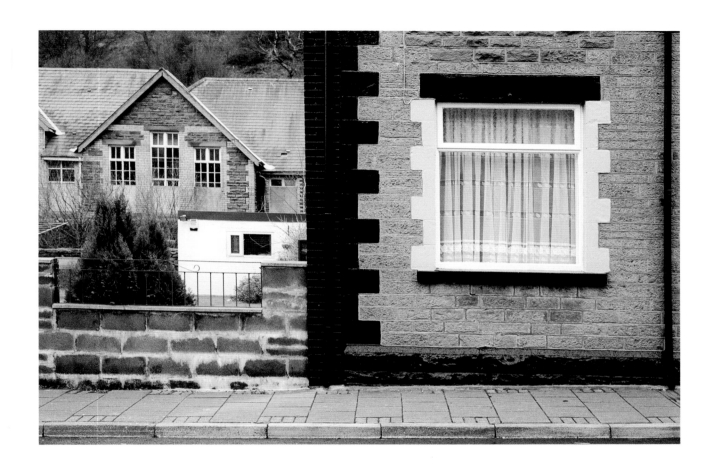

Evergreen, Blaenrhondda

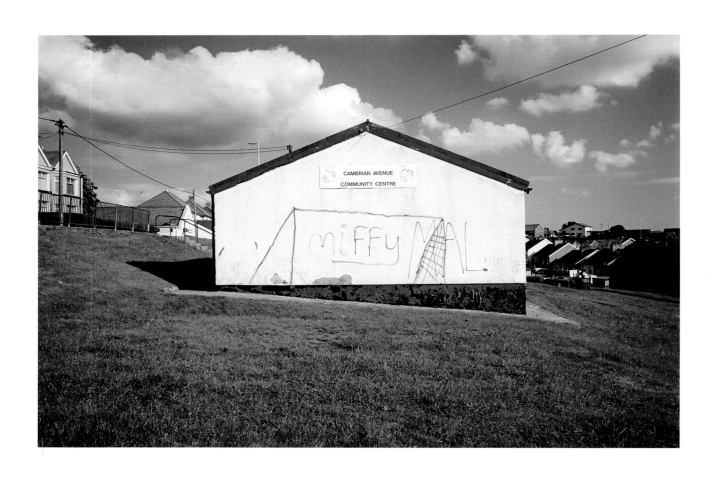

Miffy Mal, Gilfach Goch

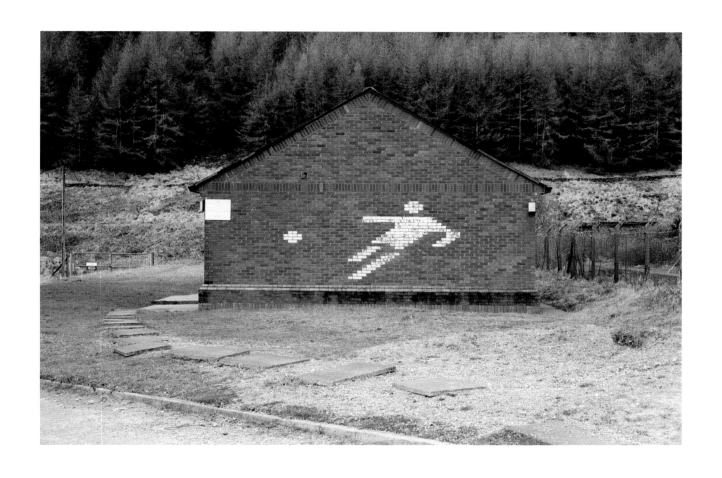

Dressing-room, Glyncorrwg

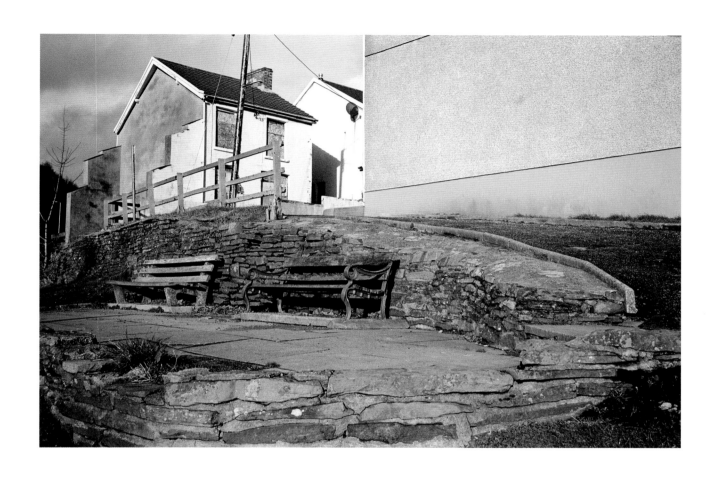

Green bench, Pontycymer

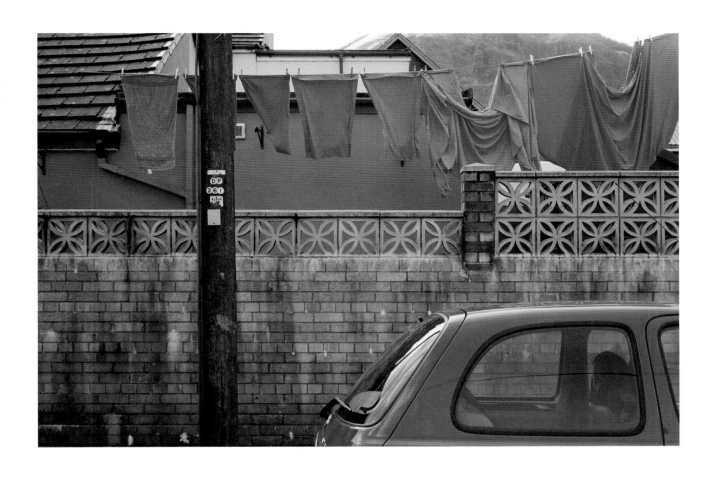

Red washing, Blaencwm

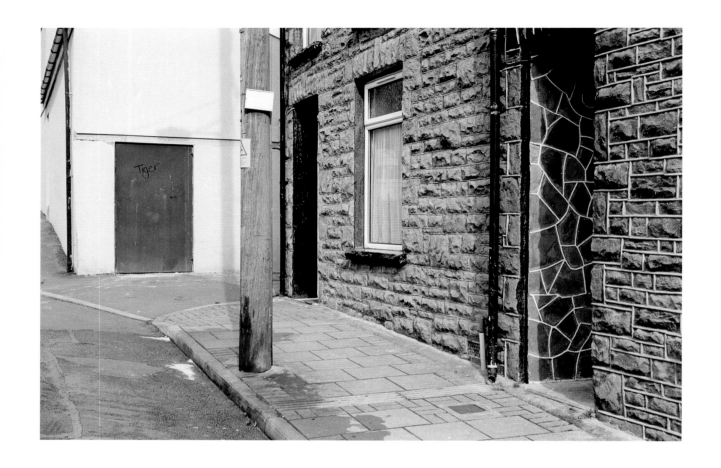

Tiger, Ton Pentre

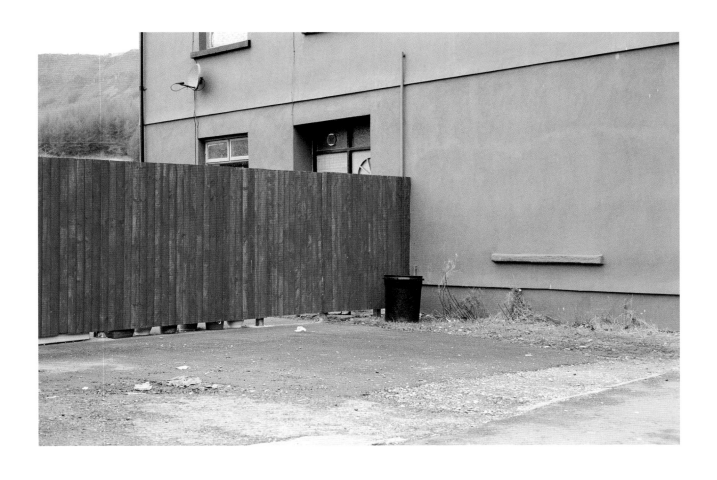

Dustbin, Ynyswen

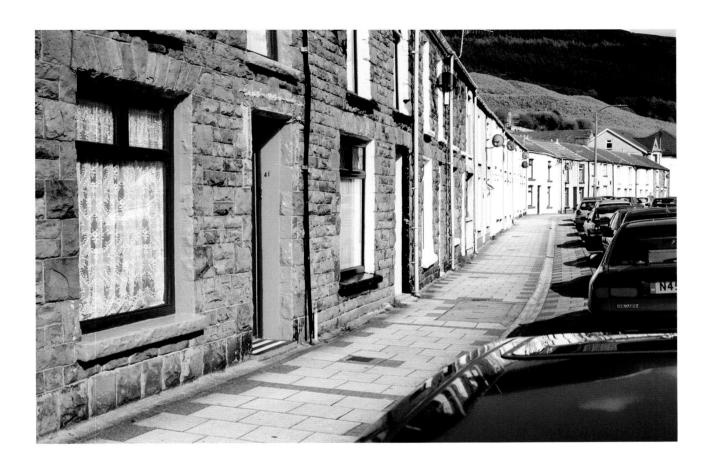

Forty-one, Treorchy

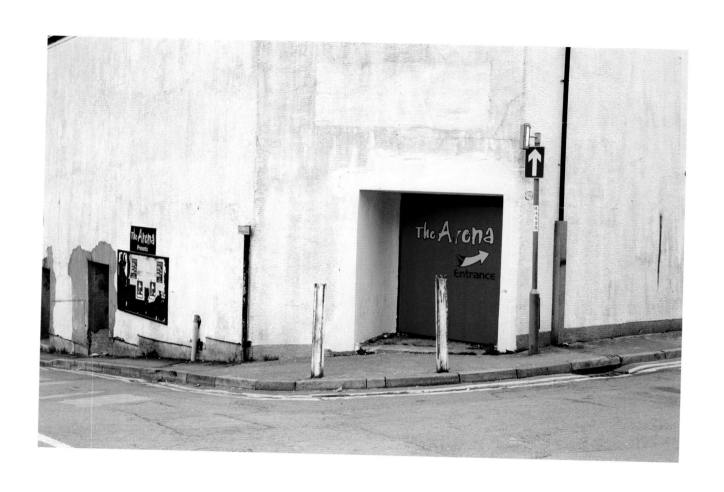

Arena, Abertillery

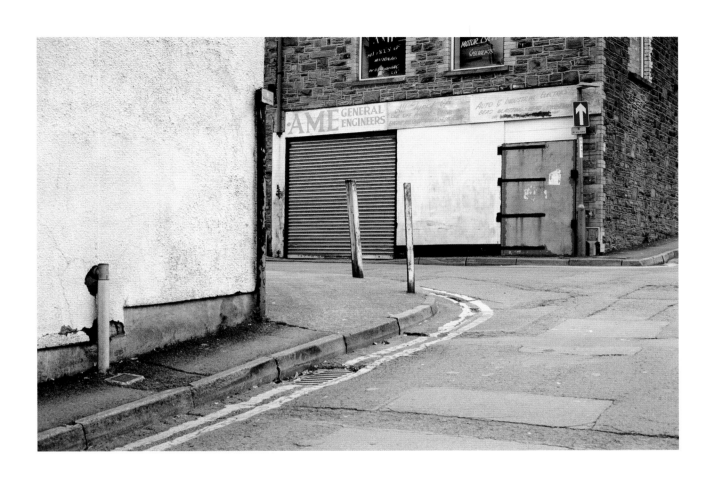

AME, Abertillery

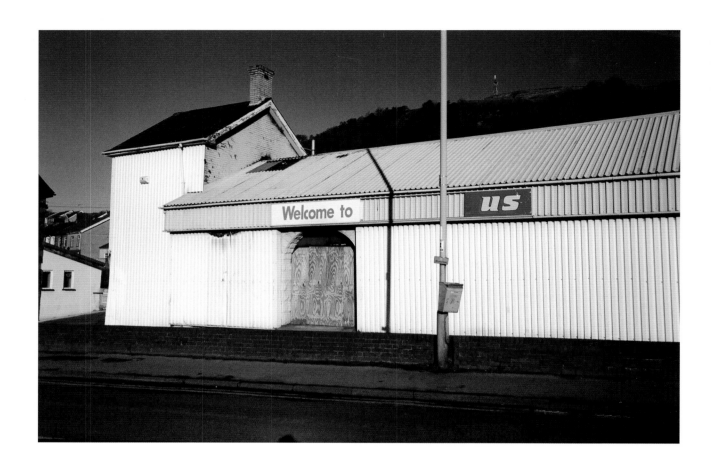

Welcome, Porth

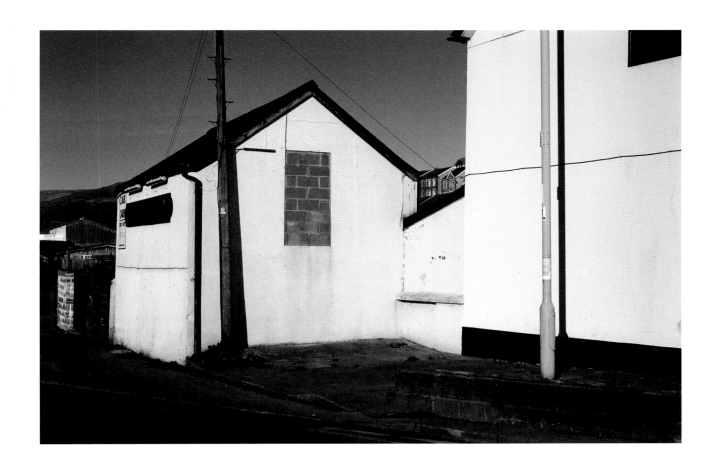

Untitled, Porth

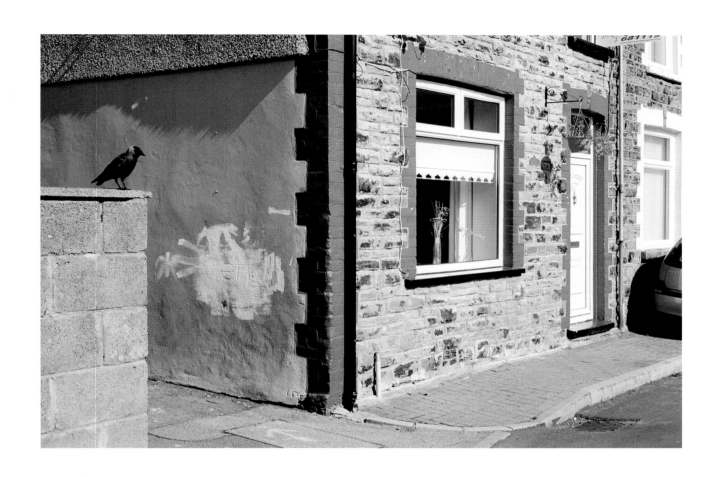

Jackdaw, Porth

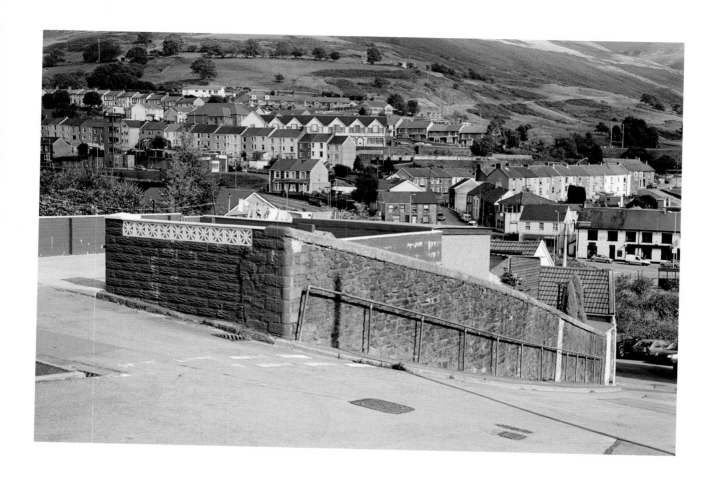

Terrace, Pontycymer

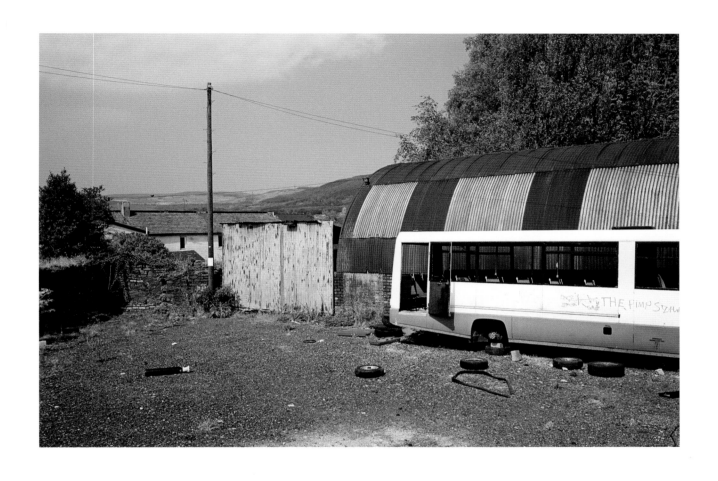

Coach, Pen-y-Graig

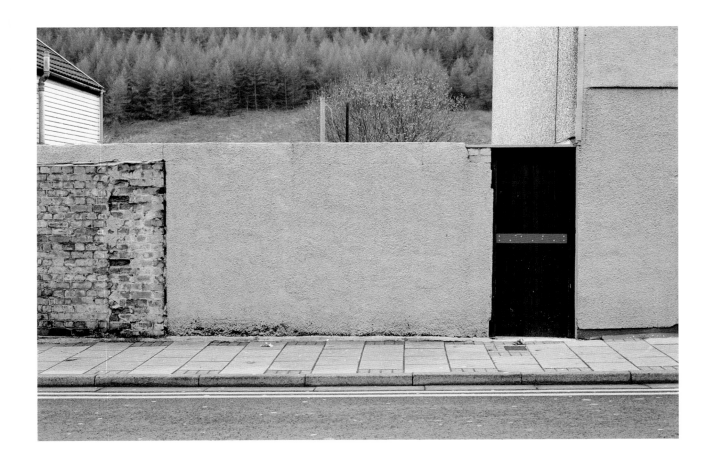

Pink wall, Tynewydd

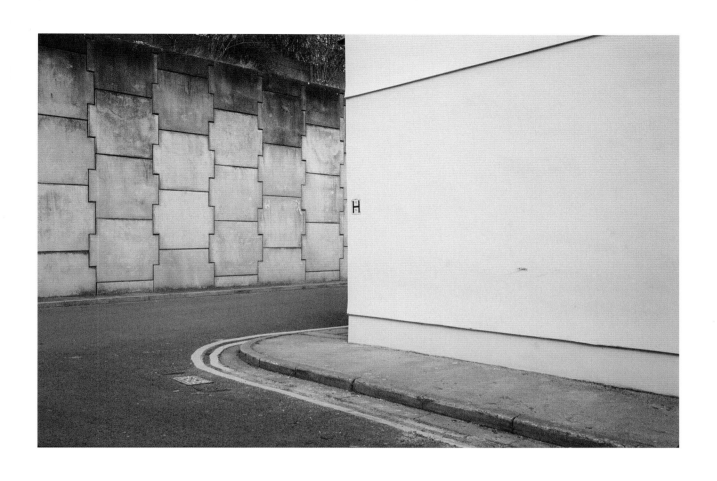

Aitch, Trehafod

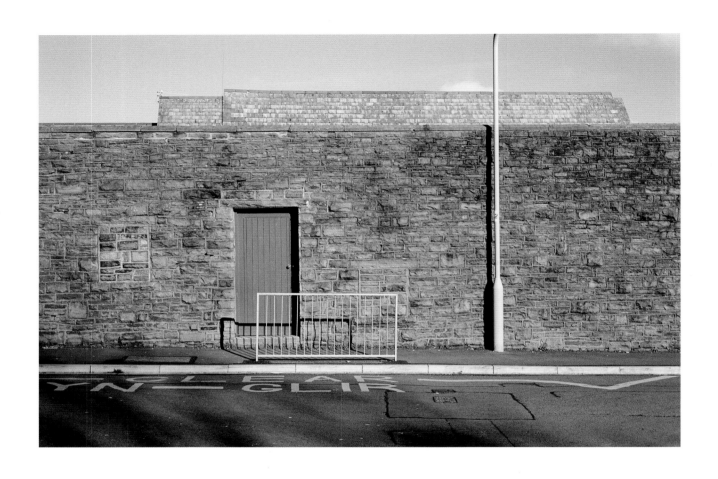

School, Aberdare

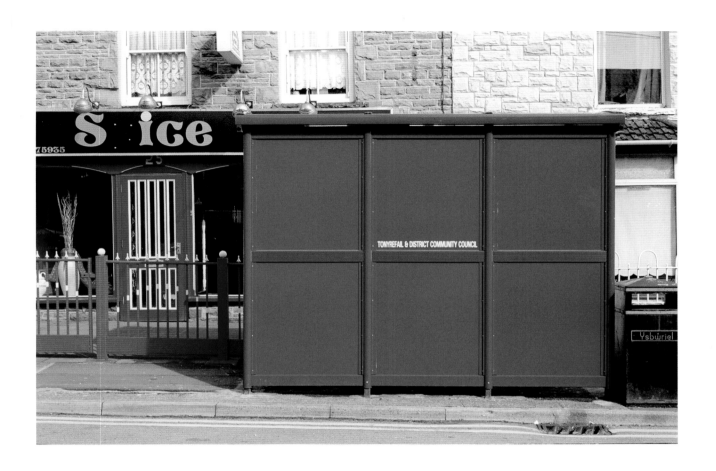

Spice, Tonyrefail

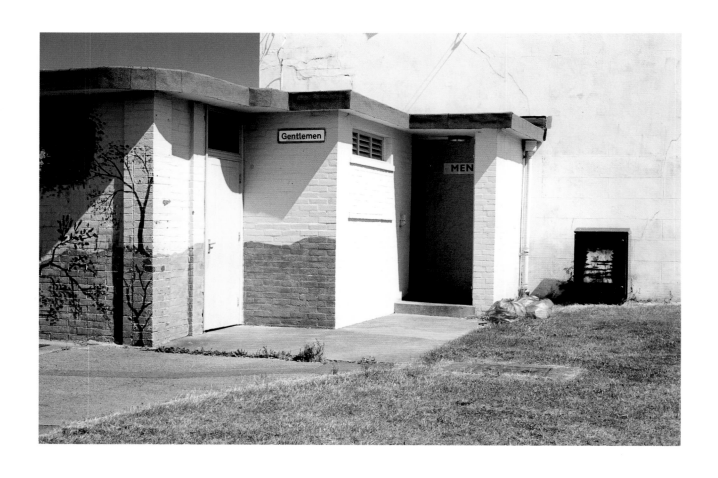

Gentlemen, Pencoed

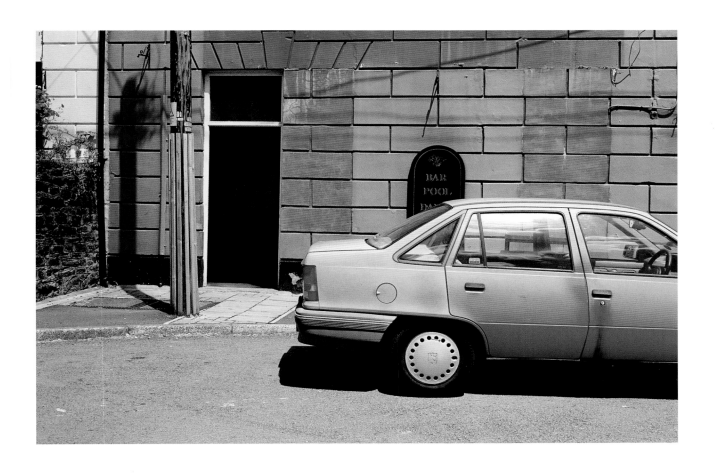

Bar, Pool, Darts, Ystrad

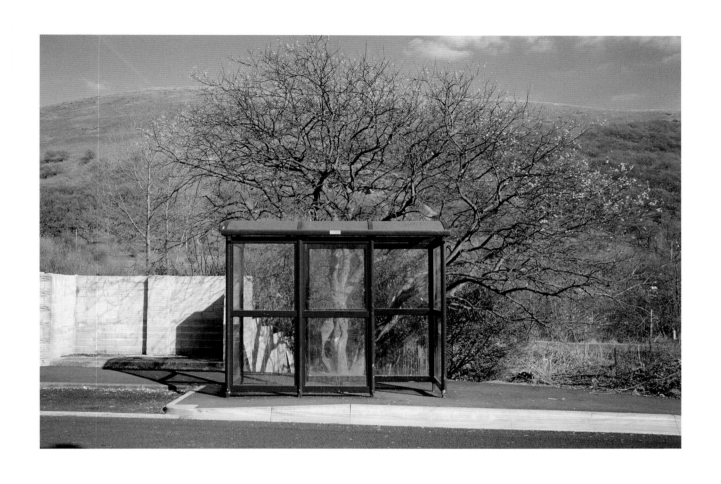

Bus Stop, Wyndham, Ogmore Vale

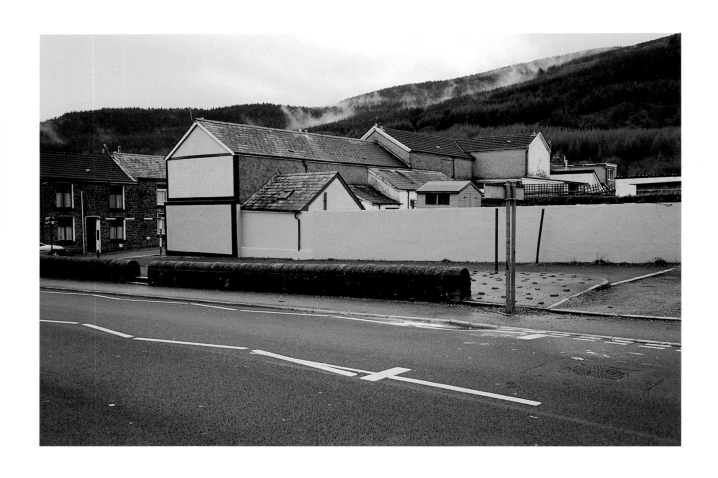

Ynyswen

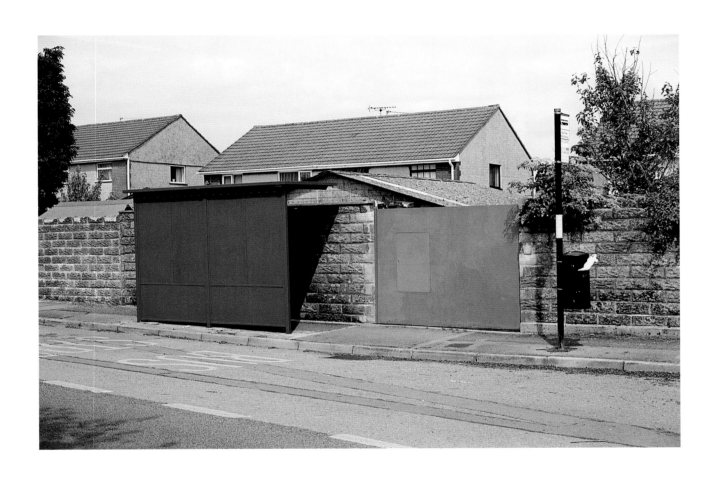

Shelter, Beddau

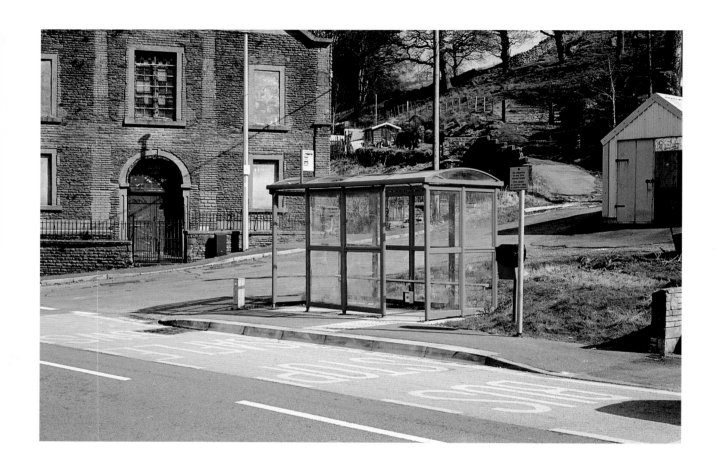

Bus shelter, Glyncorrwg

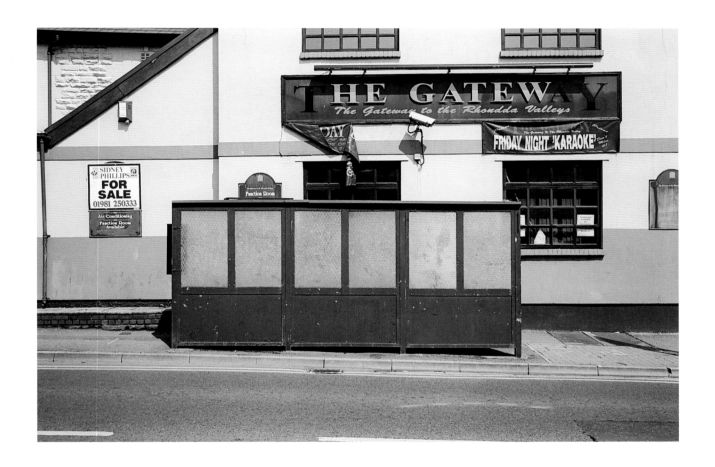

The Gateway, Porth

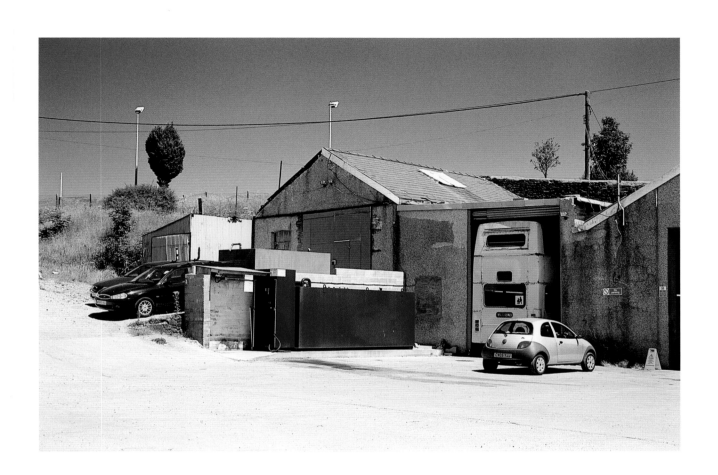

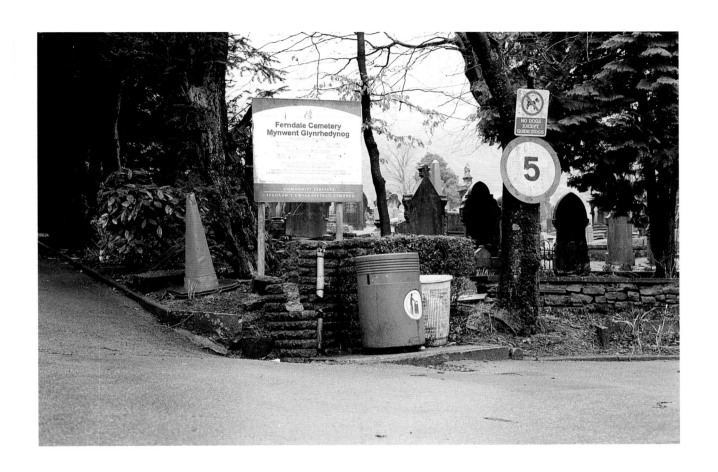

Cemetery, Ferndale

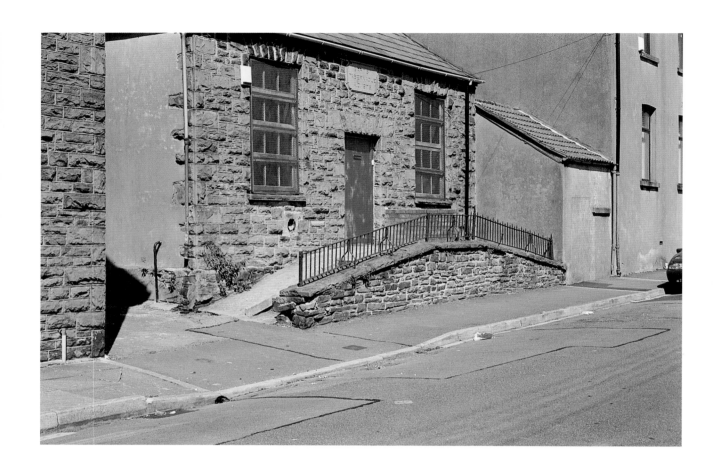

Tabernacle, Ton Pentre

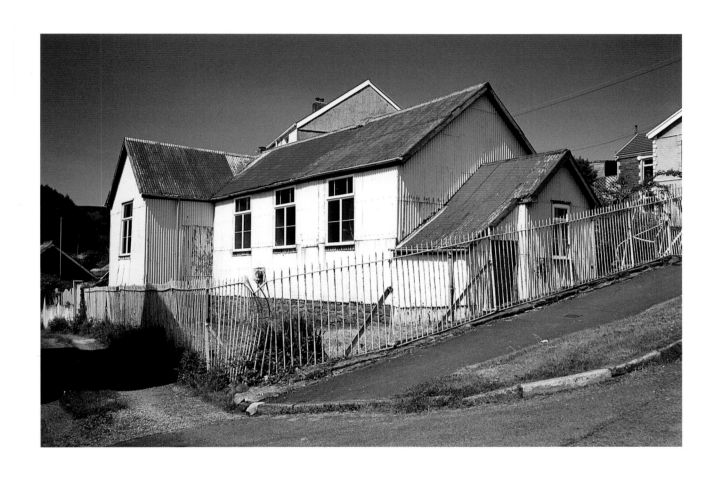

Corrugated Church, Pontycymer

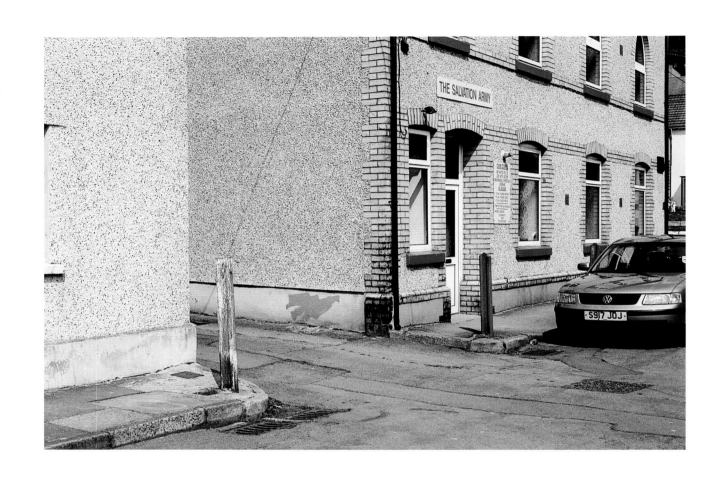

Salvation Army, Ferndale

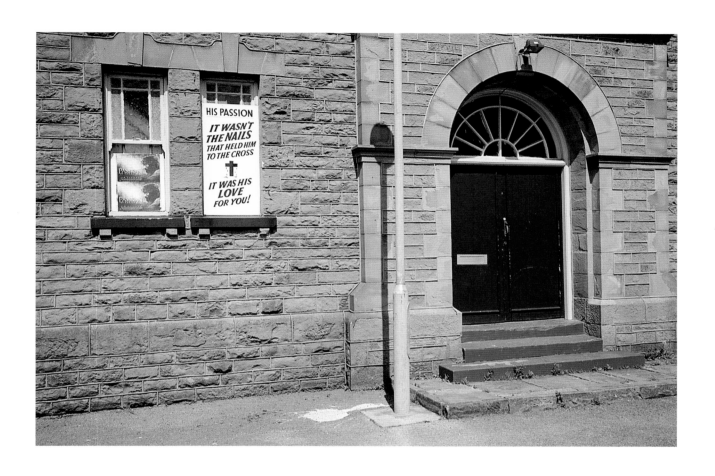

Gosen Christian Centre, Ynyswen

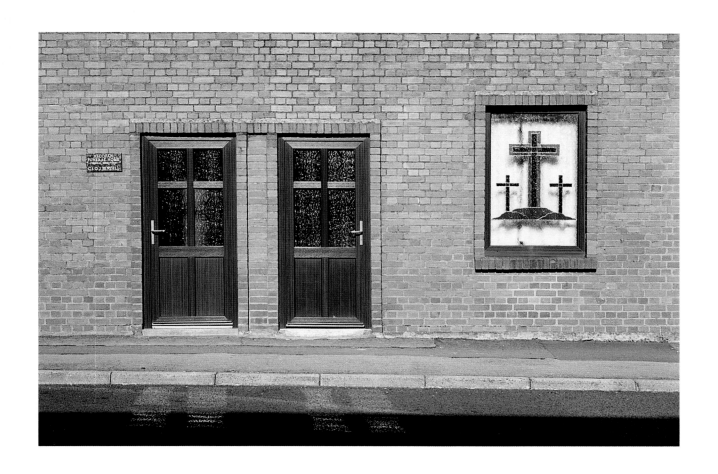

Chapel of Rest, Wyndham, Ogmore Vale

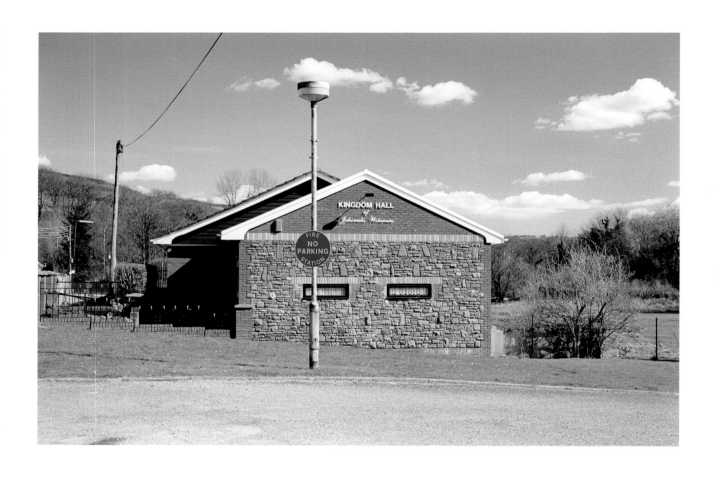

Kingdom Hall, New Tredegar

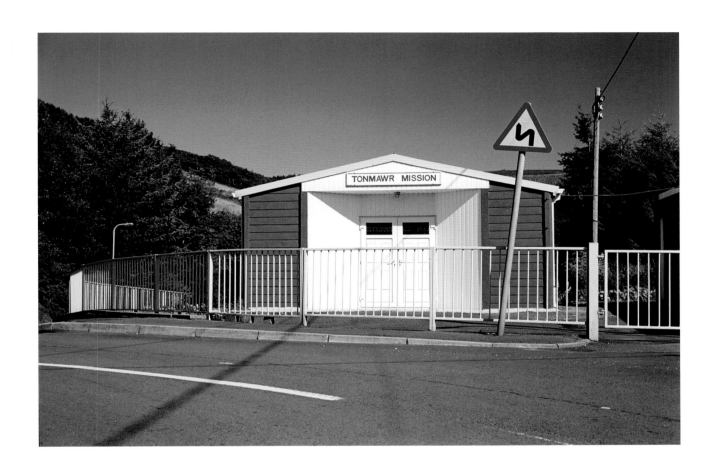

Tonmawr Mission

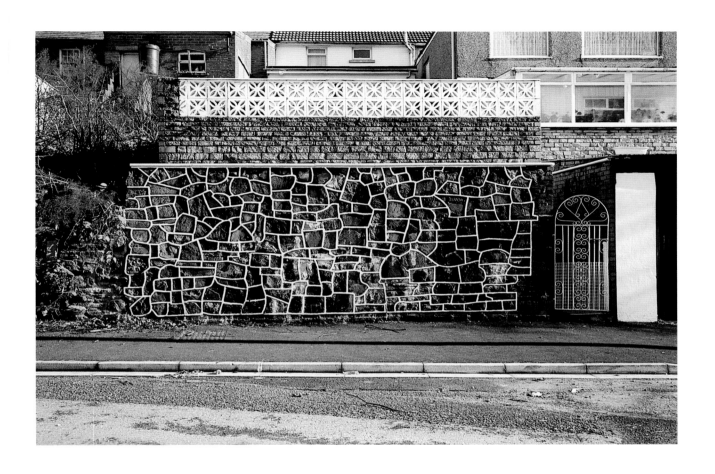

Wall, Ogmore Vale

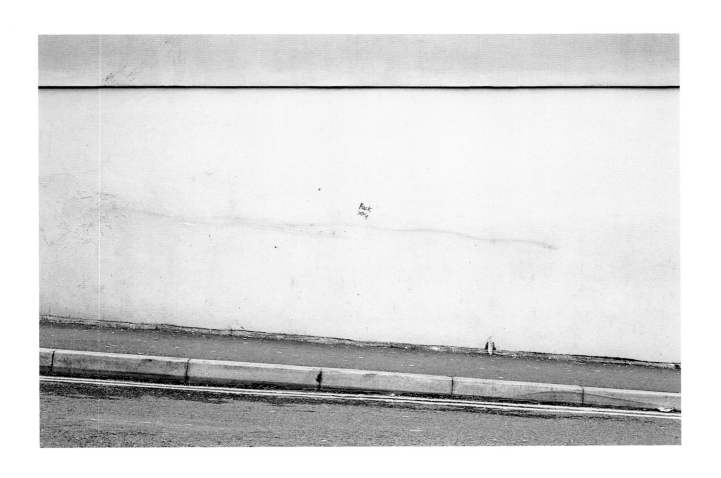

Blue wall, Ferndale

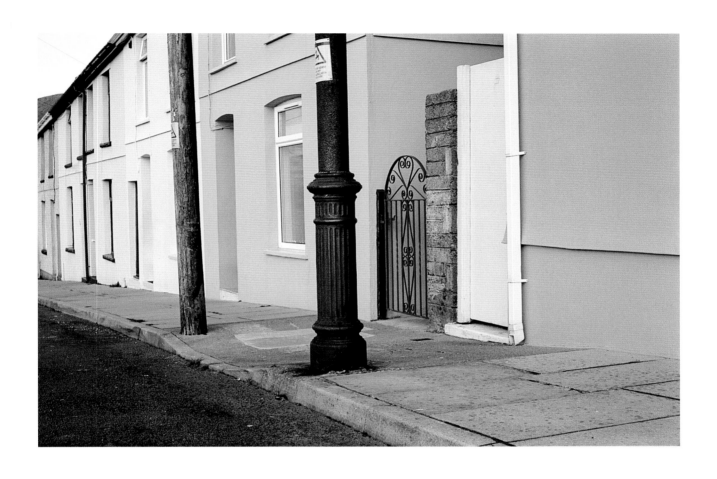

Iron lamppost, Gilfach Goch

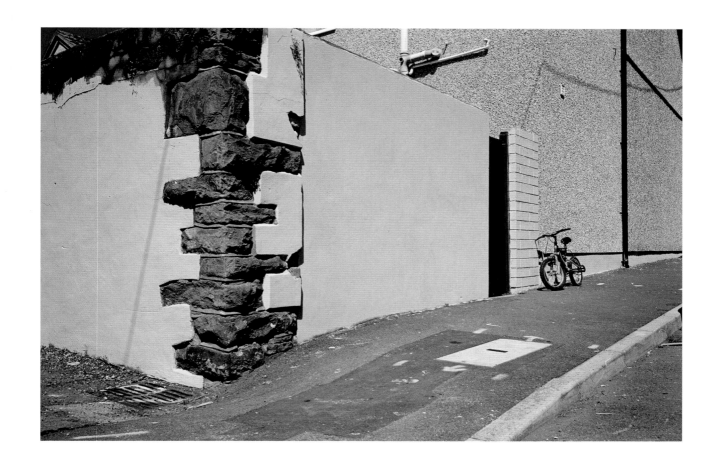

Bike, Trehafod

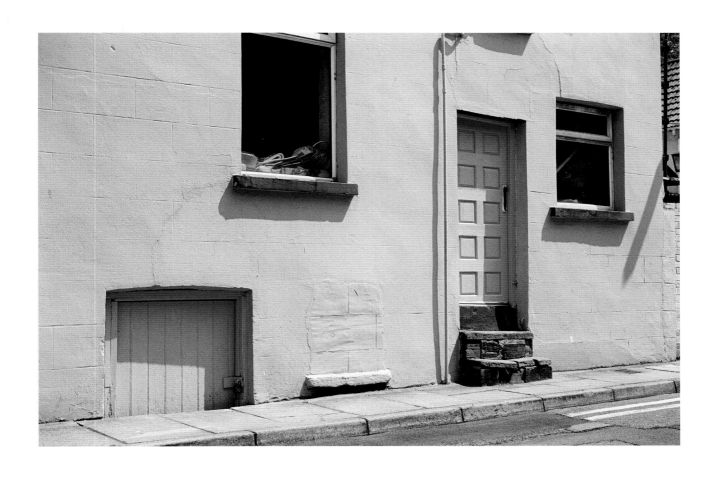

Pink door, Aberdare

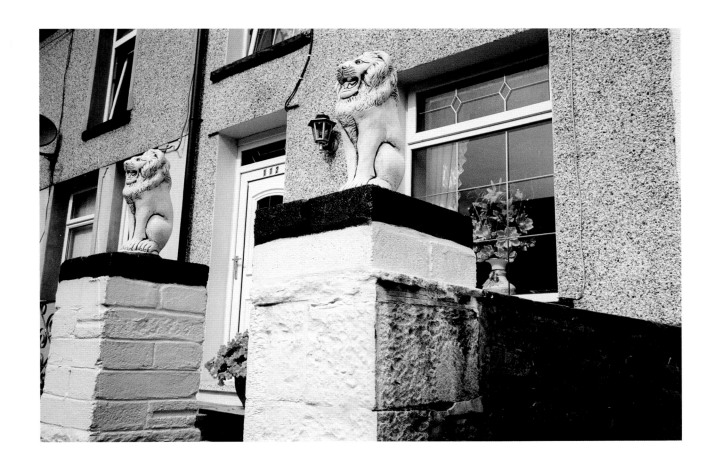

Lions, Ystrad

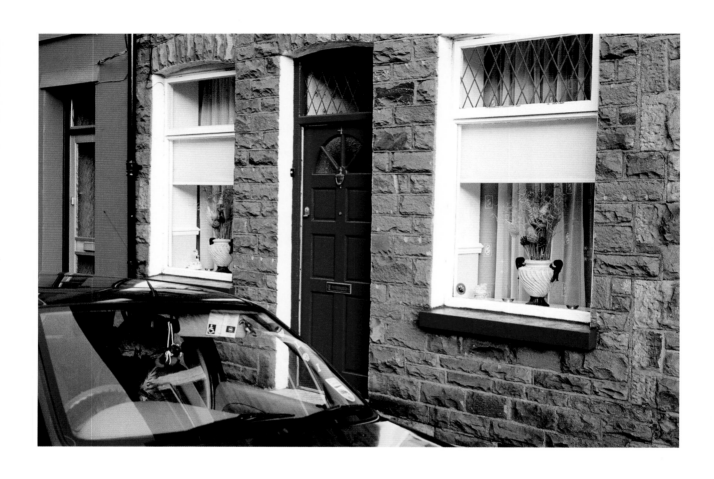

Two vases, Tonypandy

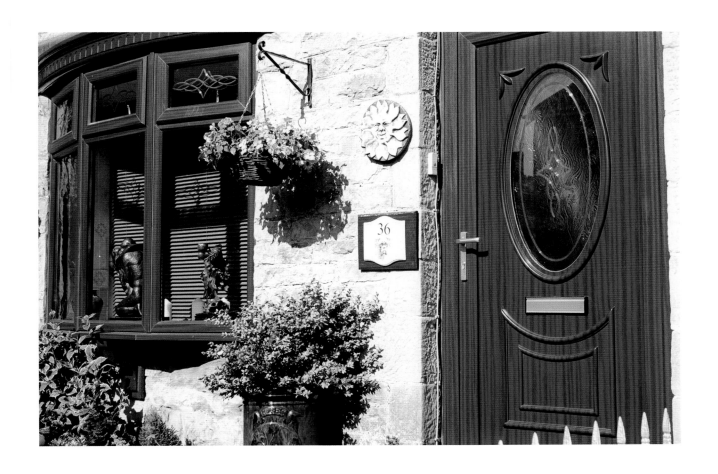

Thirty-six with lovers, Pencoed

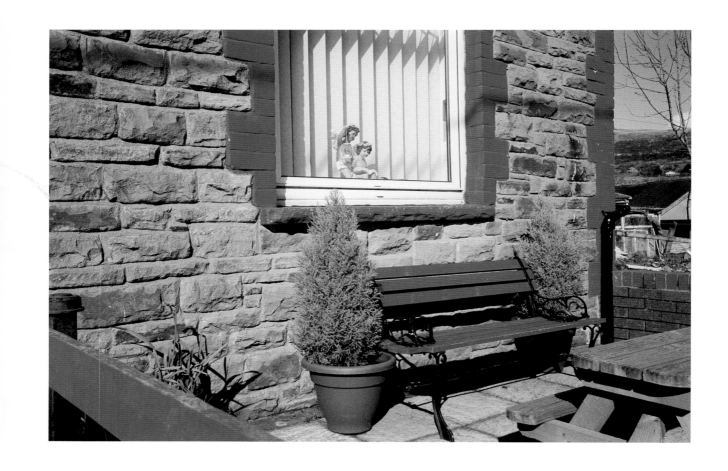

Putti, Gilfach Goch

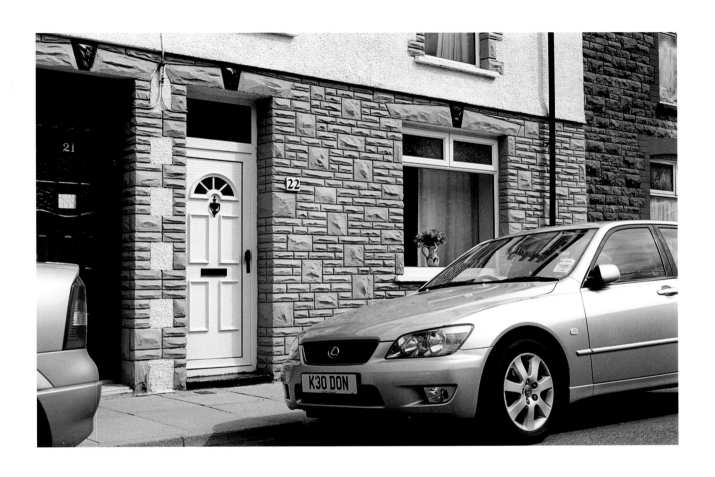

Resurfaced house with Lexus, Spelter

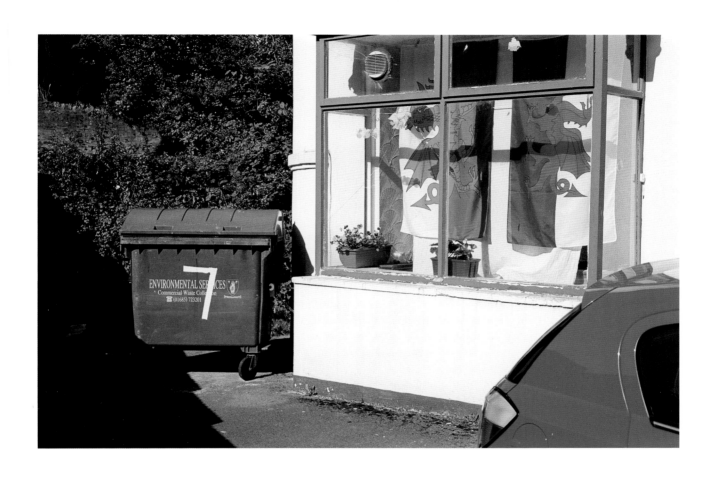

Seven, Merthyr Tydfil

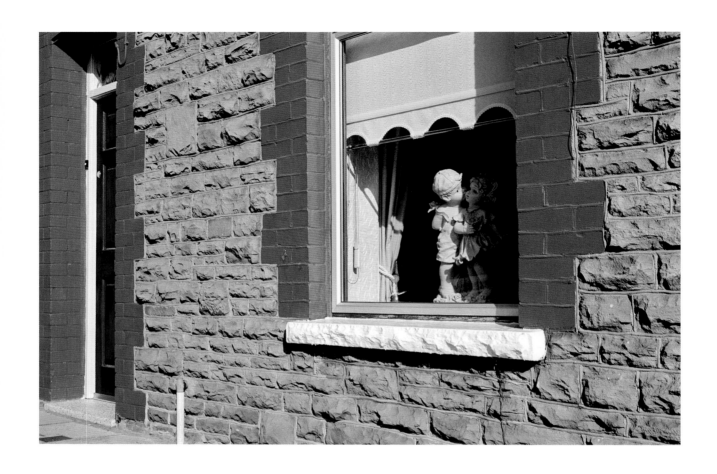

Blind

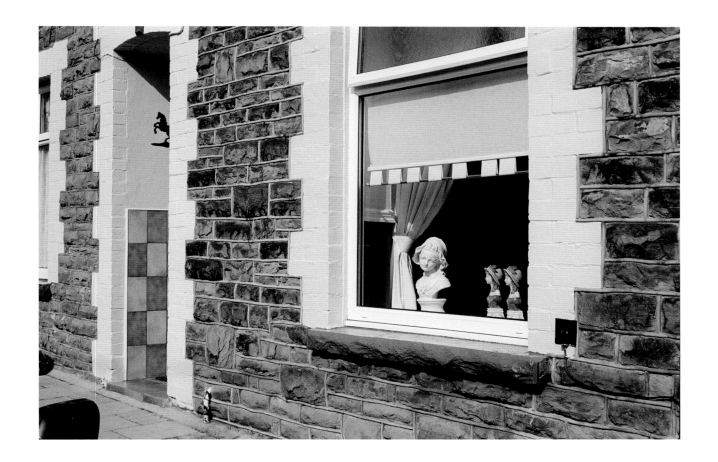

Horse

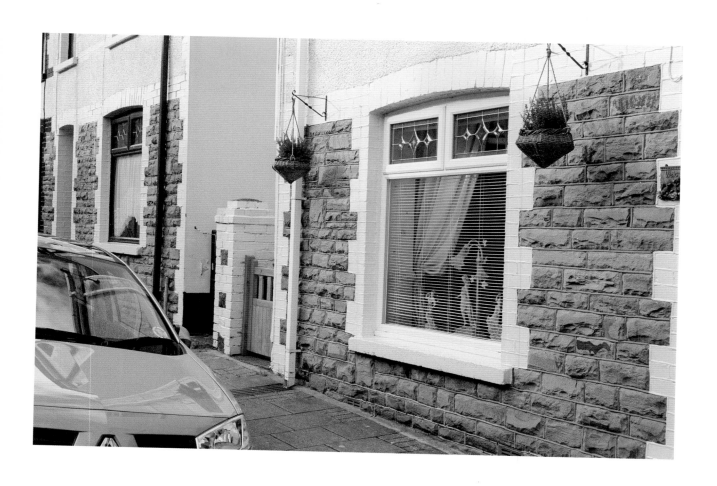

Venetian Blind, Blaencwm

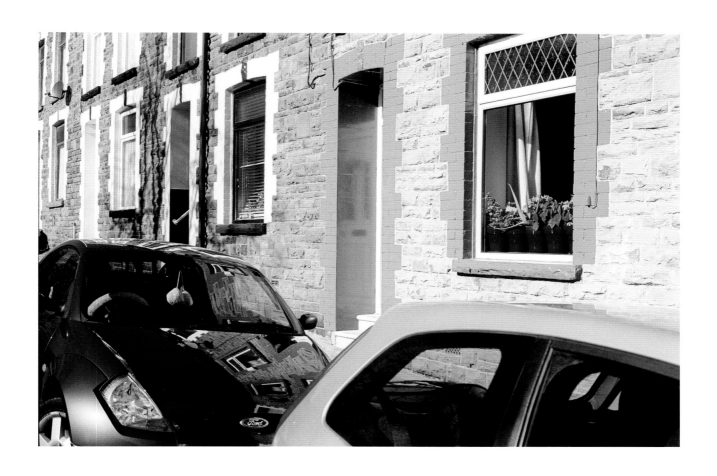

Blue pots, Cwm Parc

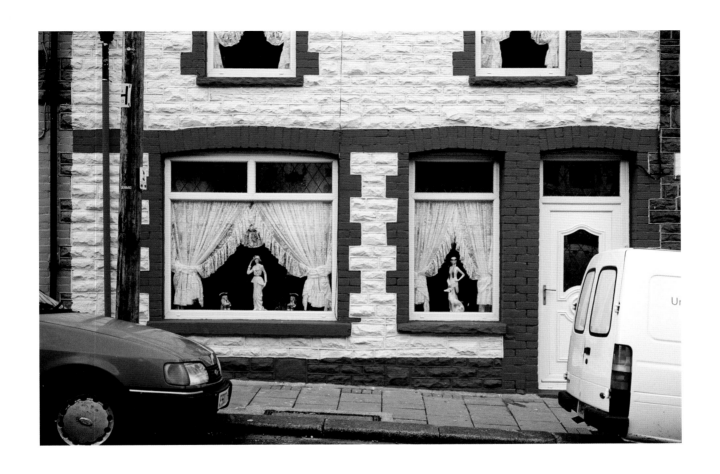

Mannequins, Ferndale

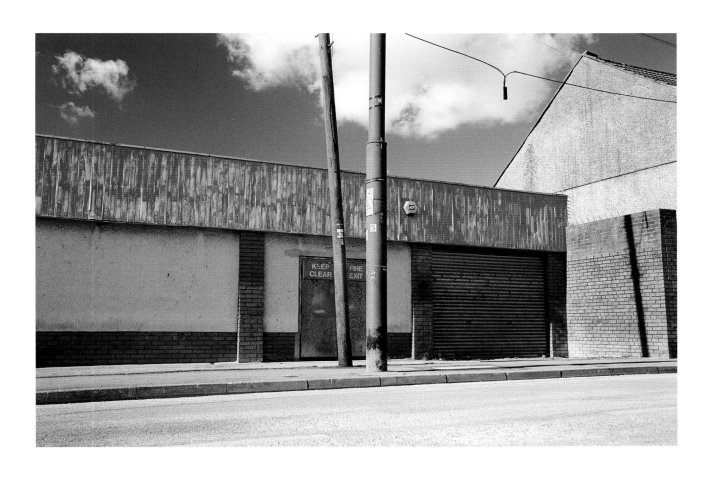

Store, Nantyffyllon

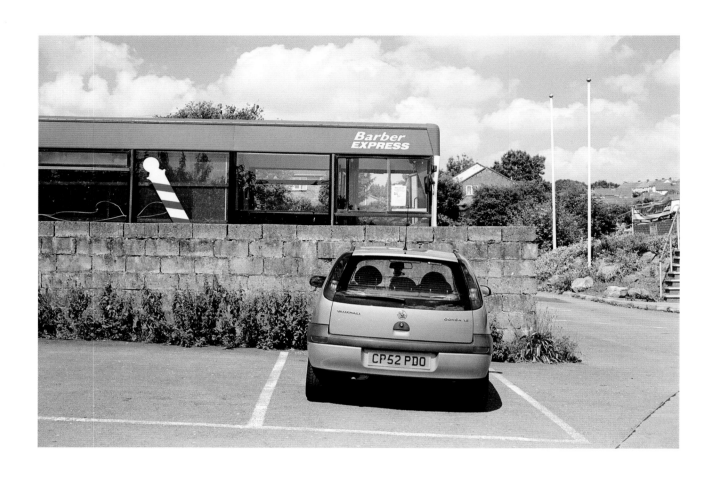

Barber Express, Pontyclun

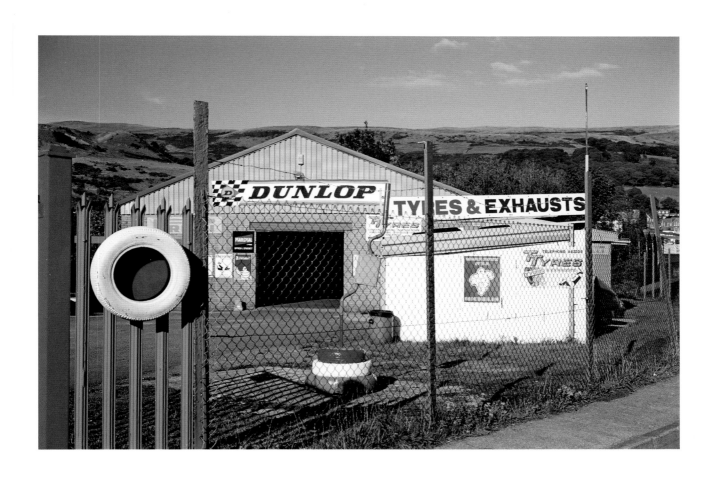

Tyres & Exhausts, Gelli

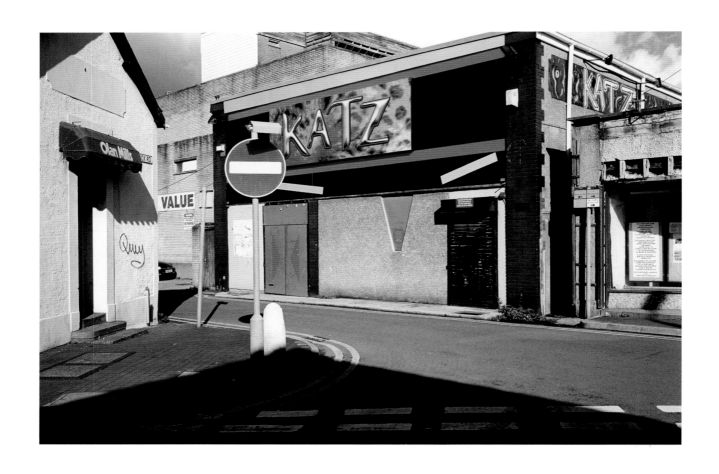

Katz, Neath

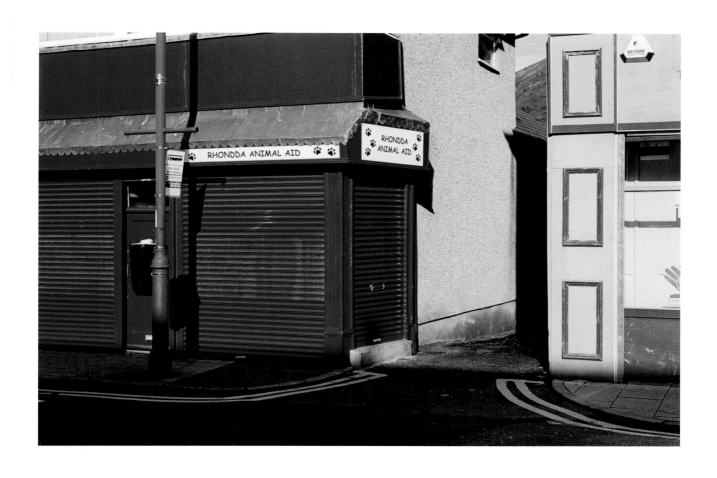

Rhondda Animal Aid, Tonypandy

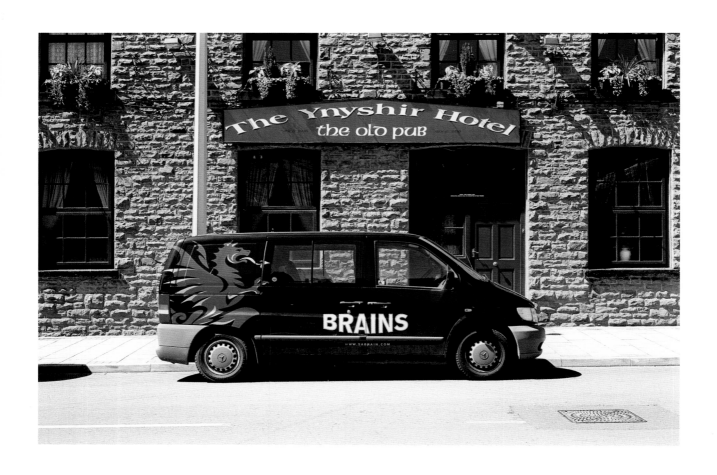

Hotel, Ynyshir

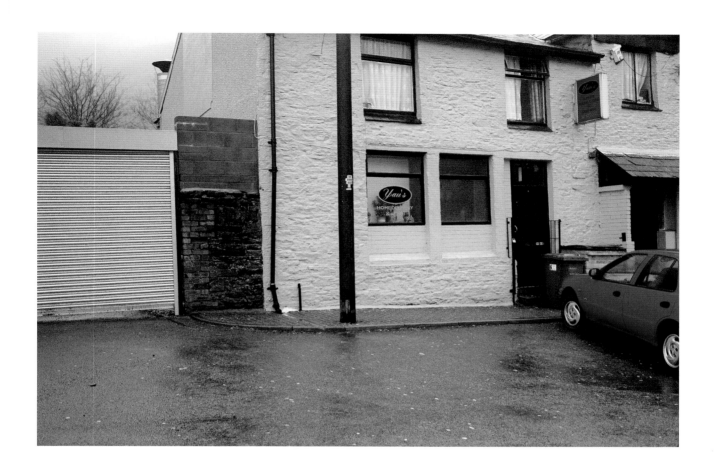

Yau's, Gilfach Goch

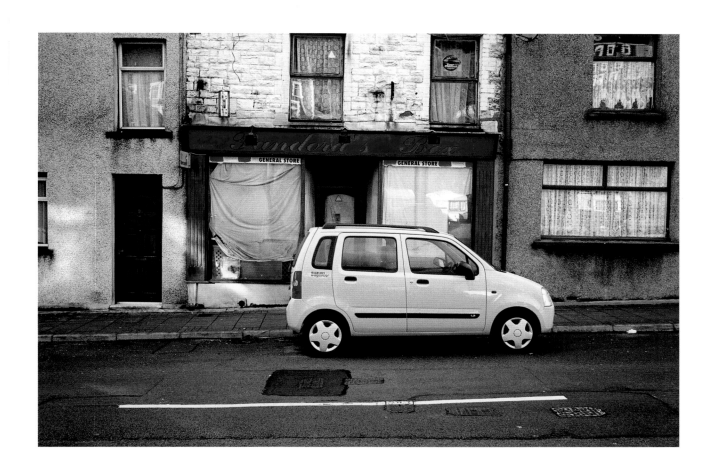

Pandora's Box, Pontycymer

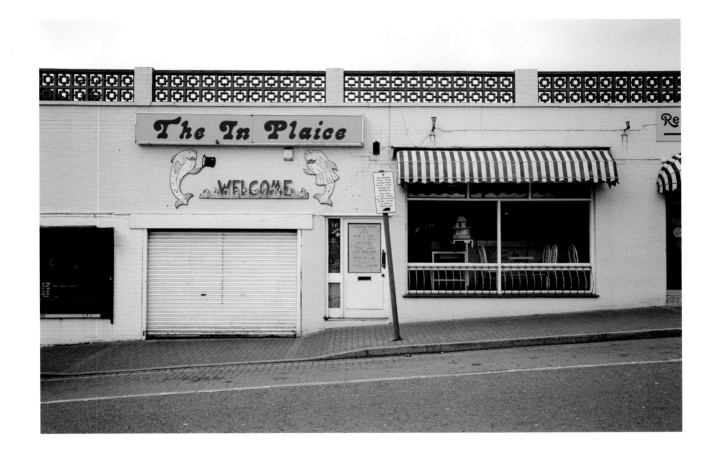

Welcome, Talbot Green

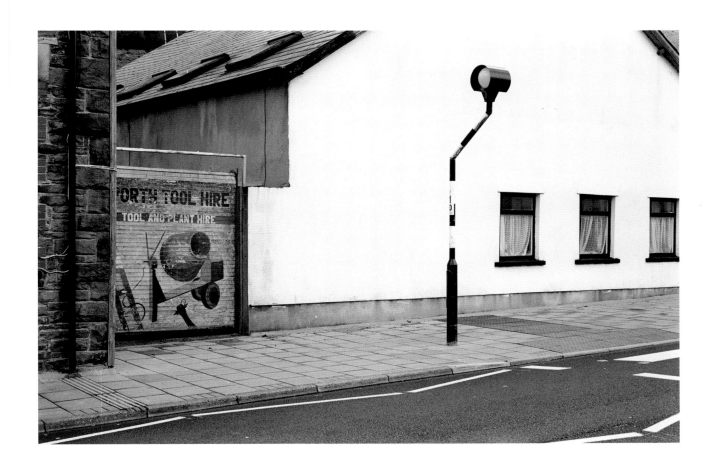

Tool Hire, Porth

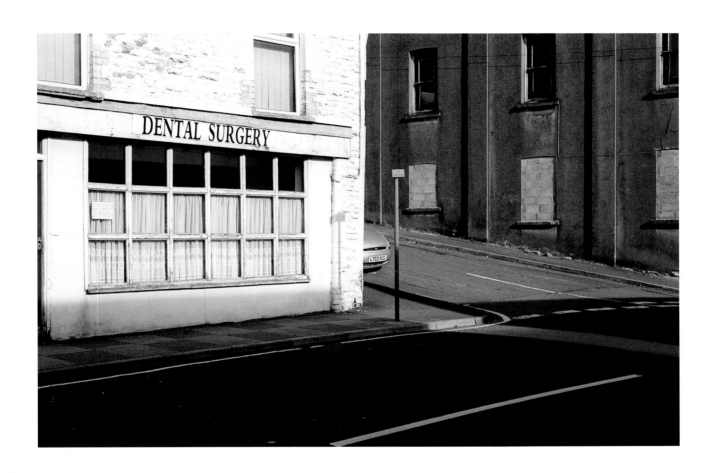

Dentist's, Nantymoel

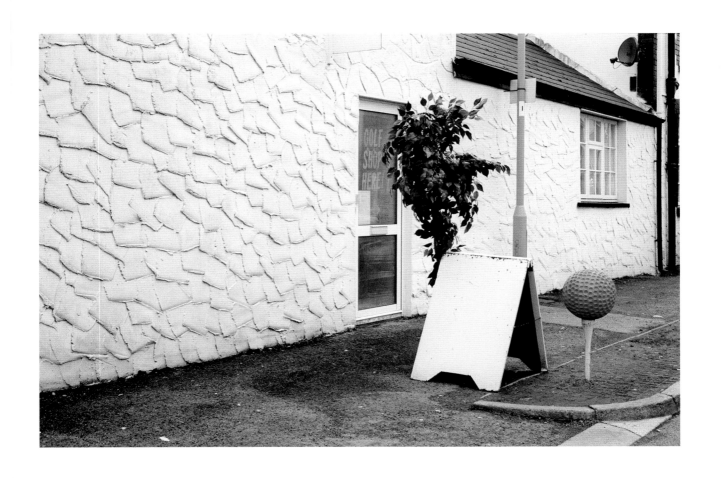

Golf, Bryncethin

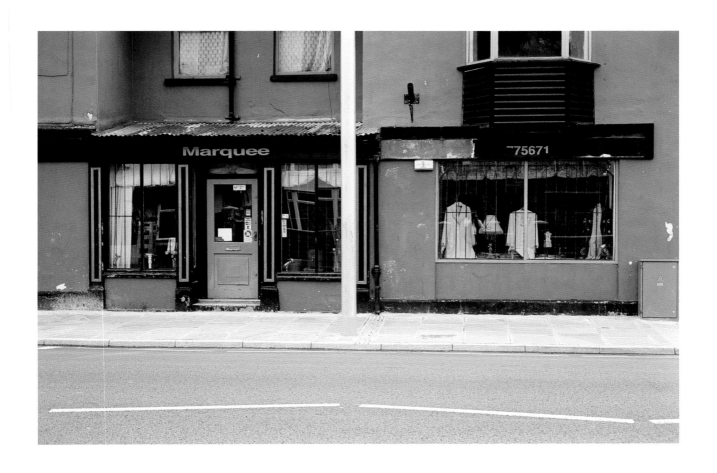

Marquee, Ynyswen

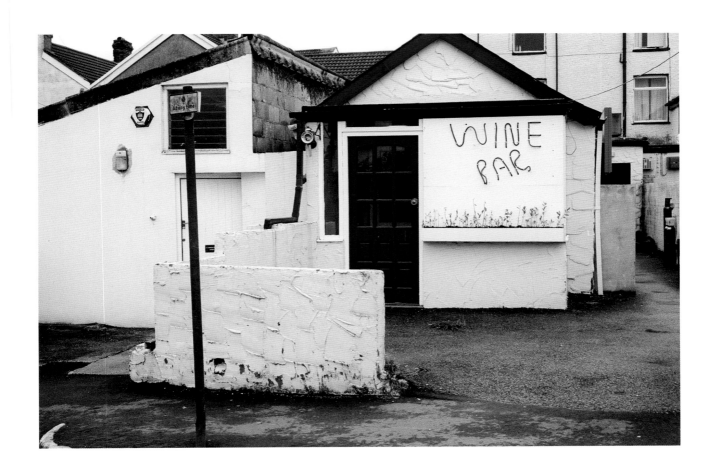

Wine bar, Aberkenfig

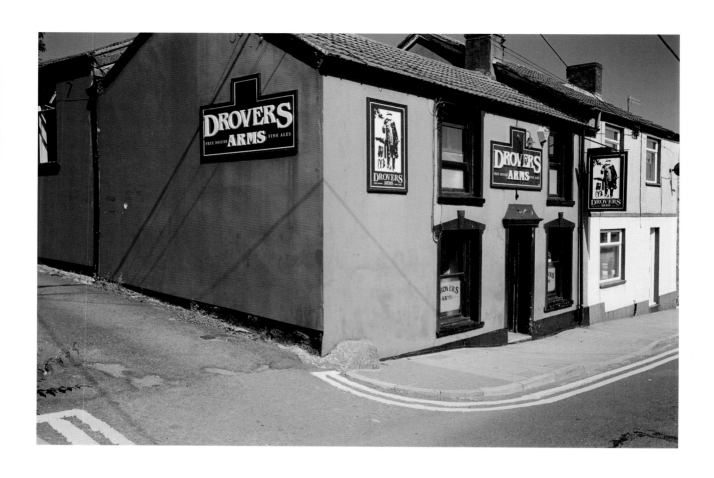

Drovers Arms, Cefn-Coed-y-Cymmer

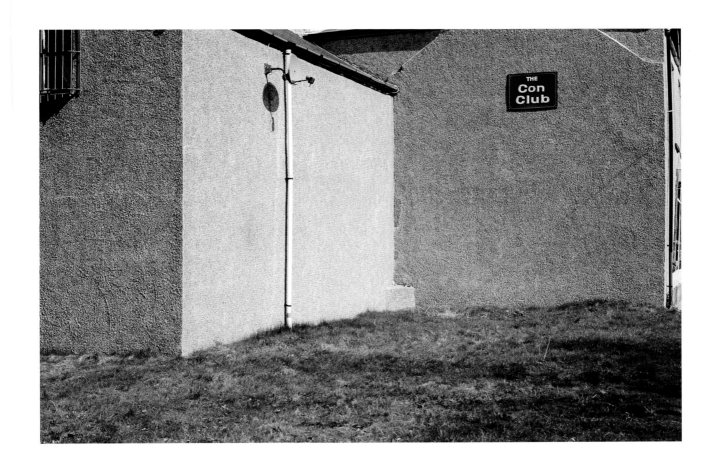

Club, Glyncorrwg

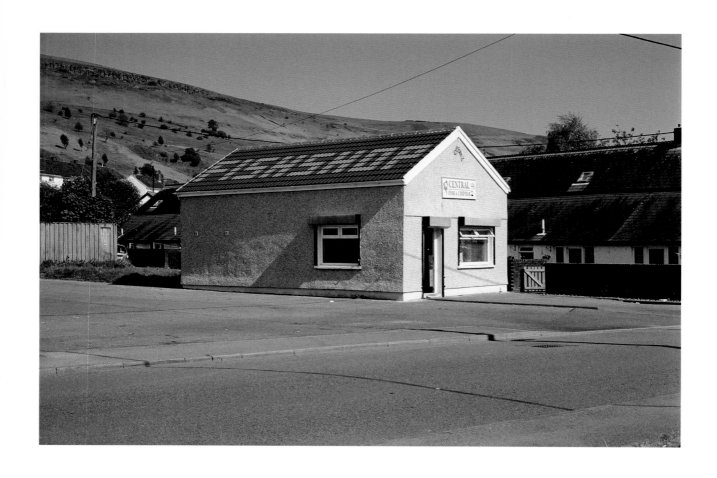

Fish, Pentrebach

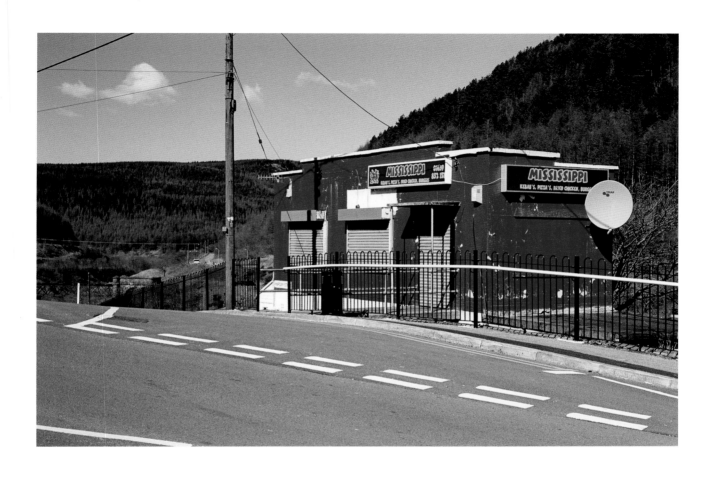

Mississippi, Cymer

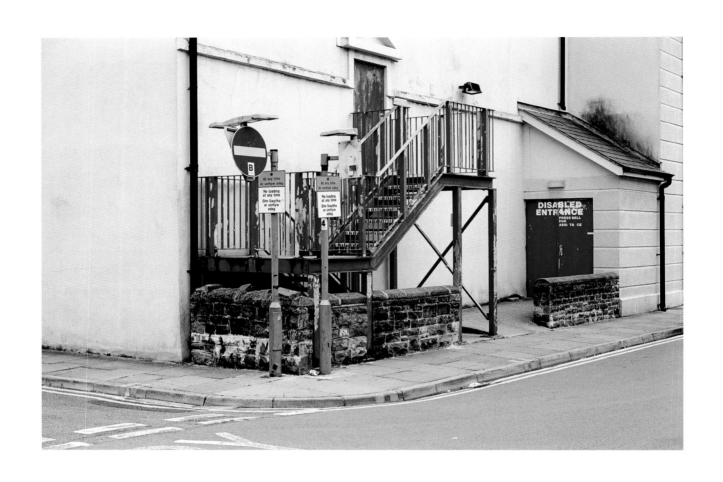

Staircase, Aberdare

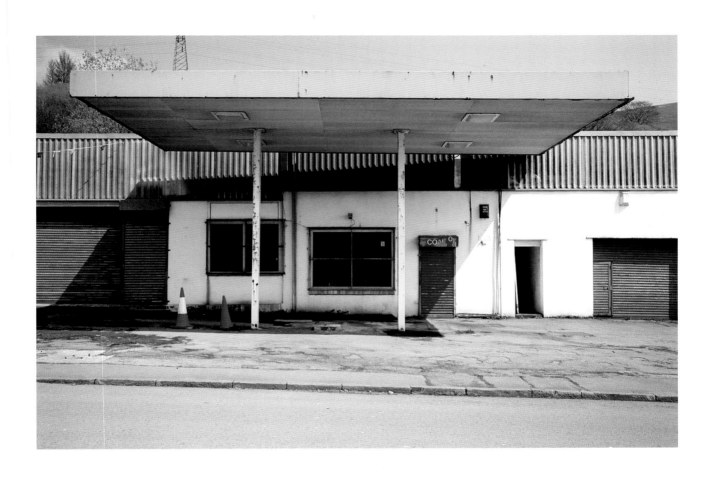

Filling Station, Cwm

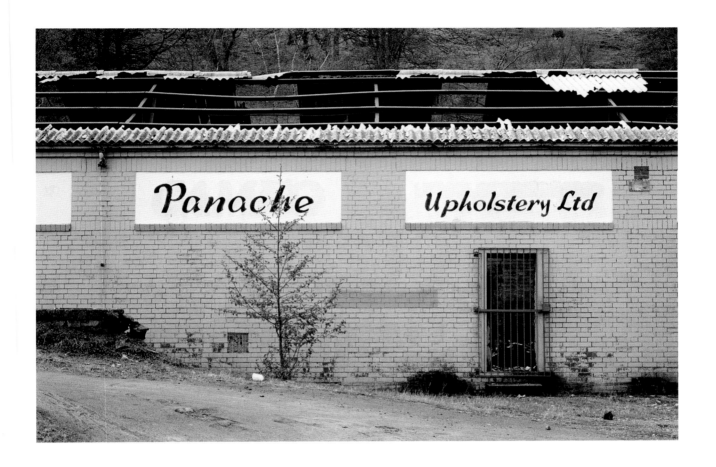

Panache, Aberbeeg

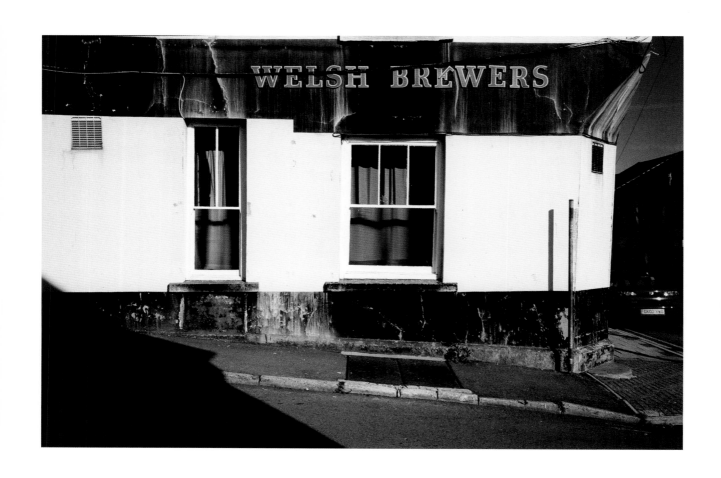

The Bush, Clydach Vale

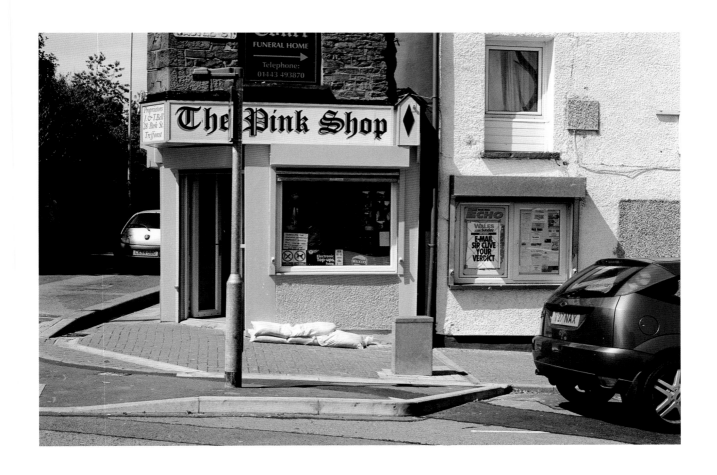

The Pink Shop, Treforest

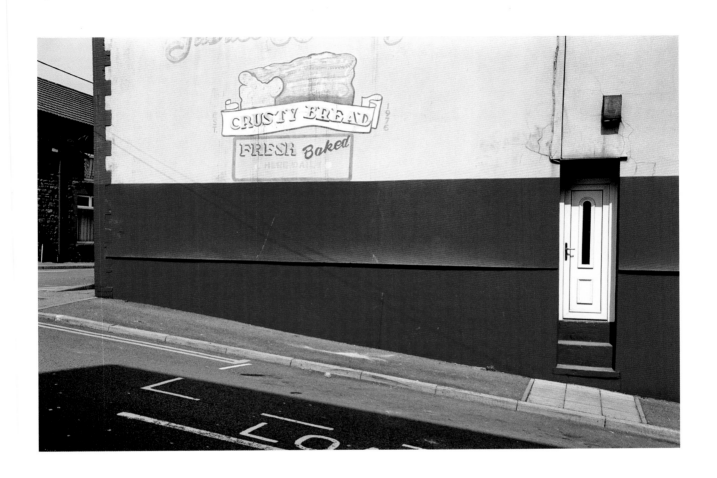

Baker, Aberaman

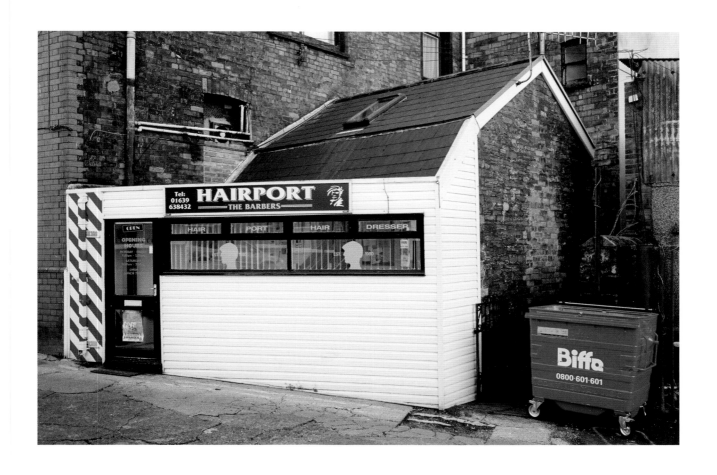

Hairport, Neath

A BIOGRAPHICAL NOTE

In 1998 my house in London fell down. Underinsured, my debts mounted while it was shored up, underpinned and rebuilt. Three years later, I left it with equity so small that it would contribute only to the purchase of a property in the cheapest place in the United Kingdom: The Valleys.

My adult life had been spent in London, working in the posh end of contemporary art, with galleries and museums; an unlikely destiny, since my Quaker father had been raised in Bridgend; my mother (then a Congregationalist) in Baglan and Merthyr Tydfil when orphaned. The mismatch occurred in Gloucester, where both tended the war-wounded at the Royal Infirmary. My father became a surveyor, my mother a nurse and housewife.

From Gloucester in the 'fifties, I often visited Merthyr and Bridgend. Although the air up the road was damper, I felt as comfy in the Heads of The Valleys as I did at the seaside; as secure with my open-hearted, plump Auntie Ada at Gwyn Fryn, Abercanaid, as when pampered by my sleek, rose-growing Gran at Holywell, Merthyr Mawr Road, Bridgend. The both. Aunt and Gran hardly knew each other. In the 'sixties, as an art student, I returned with a purpose; to draw pit-heads and railways, industry and blackness. But for the next three decades, I revisited only occasionally; to show the gorgeous, plundered town- and landscape to a friend, a wife, my daughters; or for the inevitable funerals.

Later, it took a redundancy and a bulging mortgage to shock me into a questioning quake – meltdown – and an eventual hwyl of delight. I saw the potential in a fresh start; I exchanged London for Ogmore Vale, admin for practice; and I swapped my well-worn reflex for a sharper, direct-vision, pocketable camera.

I'm lucky to have caught this profoundly important place in Wales – the power-house of the Industrial Revolution – at a time of quickening change. But its essence seems to remain intact. Only notions of conventional good taste, or coastal prejudice, are capable of obscuring the wonder of The Valleys. Could you trust a painting or a verbal description to tell the truth? Might a camera be the perfect tool to reveal such beauty?

For the pictures I was going to take I had no real plan, and I had a scant knowledge of photography and its history. (I had worked mainly with painters, sculptors and conceptual artists.) I chose colour negative film for its ease of use, its ability to accept errors, and the exciting convenience of one-hour prints at SnappySnaps. As I began to see results I also looked at important photographs at specialist galleries, the print room at the V&A in London, and in books; I bothered to read the introductory notes and other commentaries.

Only the Galapagos Islands describe the past in the present with more clarity than The Valleys. And according to these pictures, neither place is inhabited. Unlike those islands, The Valleys have few tourists. For a while, I was unaware that there were few people in my pictures. Strange, as I have albums full of holiday snapshots – all mine – portraits of daughters, family, friends and the artists I've worked for. But I've often found that I don't know what I'm doing until its done. I was well into this endeavour before I saw that Valleys people were absent. Or were they? Perhaps collectively, I hoped,

the pictures might serve as a portrait; that photography could identify, imply a people by their deeds, what they've built, modified, modernised, restored, spoilt or improved in their settlements. For the last four or five years, I've been, after all, a tourist, with only a tenuous relationship to The Valleys, but not quite a stranger.

If this is just a portrait, is it a just one? Portraits don't function well unless they have a likeness. I'm not fond of any kind of picture, including portraiture and landscape, where the subject is seen through rose-tinted glasses. I want the truth, in its entirety. Apart from having a likeness, good portraits reveal something else of the sitter: a quirk, a beauty, a characteristic trait – or something potent you can't quite place. They are personal. Have I noticed things that might ring true for Valleys people themselves? Pictures also tell us a great deal about the painter or photographer: his preferences, prejudices, strengths, inadequacies et al.

And my photographs tell me about myself; which is why I have found the experience simultaneously painful, pleasurable and, well, nourishing. It's a personal view. As I continue, the new pictures might be preferred: they're bound to change.

Forgive me if any caption is inaccurate. Just before my deadline I felt I should visit several places again in an attempt to place them correctly. Some were hard to find. They'd already changed.

ANTHONY STOKES

ACKNOWLEDGMENTS

The Valleys, as a book, is an autonomous project. But its publication coincides with an exhibition of the same title and similar content, which begins a tour at the Cynon Valley Museum in Aberdare at the end of March 2007 and travels to Oriel y Bont, University of Glamorgan, Pontypridd in the summer, and the National Library of Wales, Aberystwyth later.

The first pictures were made in 2002. Two years later I showed a boxful to Antony Owen-Hicks at the Arts Council of Wales who encouraged me to continue and has nurtured my project since. At the National Library of Wales, Michael Francis added his support and commitment, and introduced me to Christopher Wilson at the Cynon Valley Museum. Chris initiated the touring exhibition, with the financial support of the Arts Council of Wales. Dan Allen and Ceri Thomas at the University of Glamorgan also agreed to exhibit the pictures.

Towards the end of 2005, Mick Felton and Simon Hicks at Seren saw the work and invited me to make a book. Together, we asked Iain Sinclair to provide a text. The brief time I spent with Iain in The Valleys was nothing short of magical. We made no plan for our day but it passed as if guided. Iain has a way of allowing time to take its own course and to watch and listen to what it has to offer.

Dave Thomas and Graham Brekke at Davies Colour, Cardiff, scanned my negatives in preparation for this publication and produced C-type prints for the exhibition. The Cardiff Frame Company mounted the prints and Marc Arkless of Ffotogallery, Cardiff, framed them. Simon Hicks helped me to select the pictures and designed this publication. He and Jen Campbell, at Seren, also had a pivotal role in the presentation and promotion of the exhibition at the Cynon Valley Museum.

I am very happy that the whole caboodle has been done here in Wales, and I am grateful to those mentioned above and their teams.

The Talgarth Bakery is in the heart of Robert Frank territory. Howard Hughes is Managing Director there and I want to thank him for easing the costs of this publication. Davies Colour in Cardiff and HSW Print in Tonypandy provided services in kind and I am grateful to them too.

I also want to thank Sarah Wedderburn for an encouragement that went much further than showing me which pictures might do. And David Alston for some persuasive advice, given with such kindness and conviction, that I believe he might have saved me from shooting myself in the foot.

Shortly before she died last year, my cousin Glenys, a nurse from Dowlais – Auntie Ada's daughter – saw most of the prints reproduced here. Like her mother, she was warm and unusually frank. I was glad when she said the pictures were lovely. They are dedicated to our memories of her.

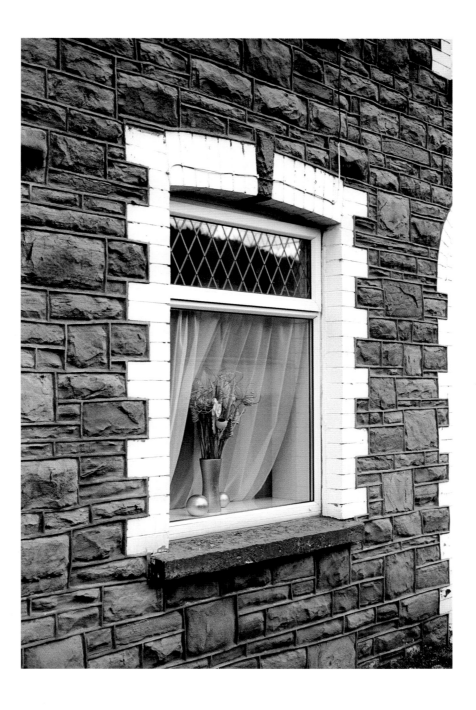

Seren is the book imprint of
Poetry Wales Press Ltd
57 Nolton Street, Bridgend, CF31 3AE, Wales
www.seren-books.com

Introduction © Iain Sinclair
Photographs © Anthony Stokes
First published in 2007 to coincide with an
exhibition at the Cynon Valley Museum, Aberdare

ISBN 978-1-85411-444-0
A CIP record for this title is available from
the British Library

Printed in Gill Sans by HSW Print, Tonypandy

Seren works with the financial assistance of the
Welsh Books Council

The publisher would like
to thank Davies Colour,
HSW Print and Talgarth
Bakery for their generous
sponsorship of this
publication